PRESSED IN TIME

PRESSED IN TIME

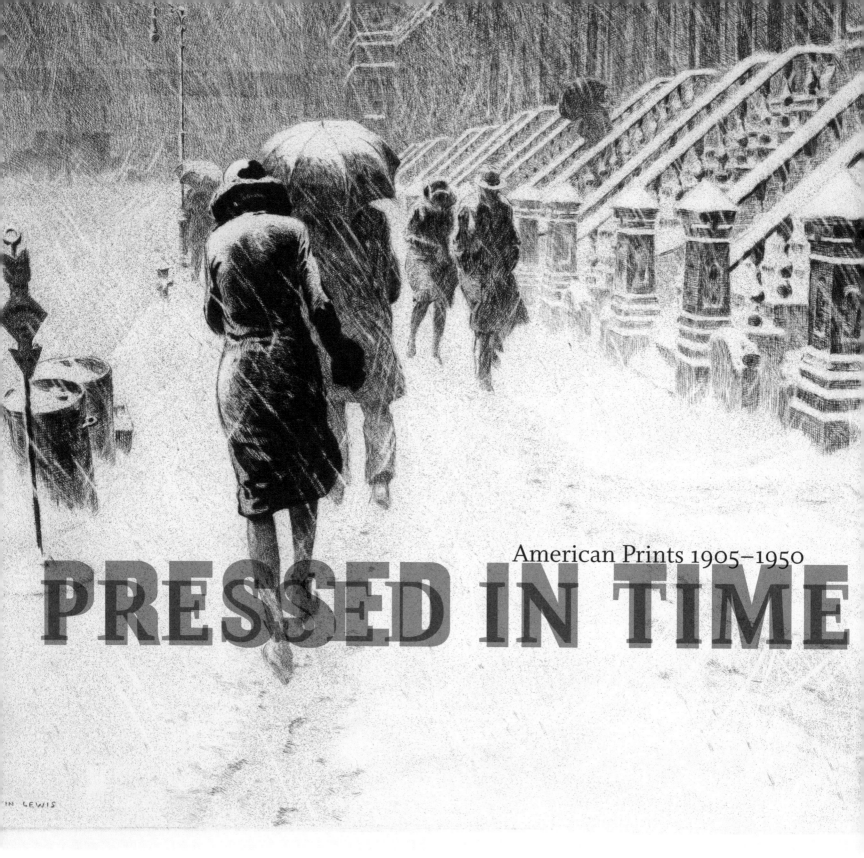

American Prints 1905–1950

PRESSED IN TIME

IN LEWIS

The Huntington Library, Art Collections, and Botanical Gardens
San Marino, California

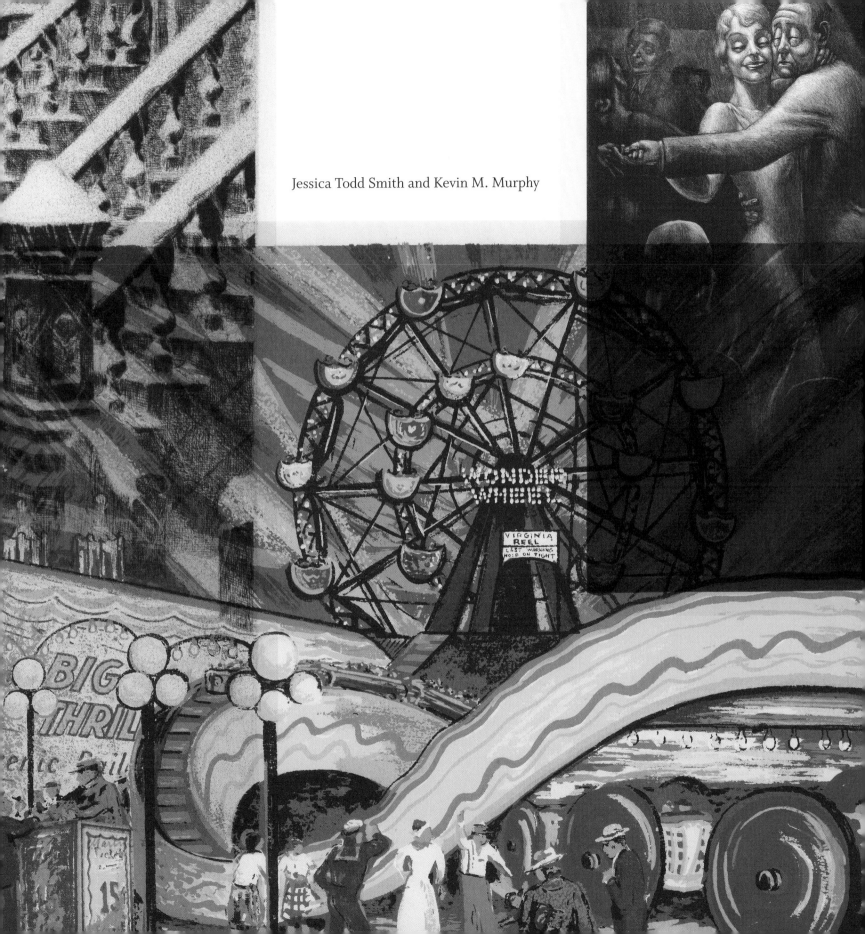

Jessica Todd Smith and Kevin M. Murphy

Copyright 2007
Henry E. Huntington Library and Art Gallery
1151 Oxford Road, San Marino, CA 91108
www.huntington.org

Designed by Zach Hooker
Edited by Martin Fox
Proofread by Sharon Rutberg
Typeset by Brynn Warriner
Color separations by iocolor, Seattle
Produced by Marquand Books, Inc., Seattle
 www.marquand.com
Printed and bound in Singapore by
CS Graphics Pte., Ltd.

Library of Congress Cataloging-in-Publication Data
Henry E. Huntington Library and Art Gallery.
 Pressed in time : American prints, 1905–1950 /
Jessica Todd Smith and Kevin M. Murphy.
 p. cm.
 Catalog of an exhibition at the Huntington Library,
Art Collections, and Botanical Gardens, Oct. 6,
2007–Jan. 7, 2008.
 ISBN: 978-0-87328-234-5 (alk. paper)
 1. Prints, American—20th century—Themes,
motives—Exhibitions. 2. Prints—California—
San Marino—Exhibitions. 3. Henry E. Huntington
Library and Art Gallery—Exhibitions. I. Smith,
Jessica Todd. II. Murphy, Kevin M. III. Henry E.
Huntington Library and Art Gallery. IV. Title.
NE508.H46 2007
769.973'07479493—dc22 2007018544

Cover (back left to front right):
 Michael Gallagher, *Scranton Coal Miners* (detail)
 Ida Abelman, *Wonders of Our Time* (detail)
 Gustave Baumann, *Singing Woods* (detail)
 John Taylor Arms, *West Forty-Second Street, Night*
 (detail)
 Riva Helfond, *Patterns for Victory* (detail)
 Martin Lewis, *Glow in the City* (detail)
Frontispiece:
 Martin Lewis, *Stoops in Snow* (detail)
 Harry Shokler, *Coney Island* (detail)
 Kyra Markham, *Night Club* (detail)
Pages 4–5:
 Paul Landacre, *Death of a Forest* (detail)
 Benton Spruance, *American Pattern—Barn* (detail)
 Leon Bibel, *Descending* (detail)
Pages 8–9:
 Franz Geritz, *Craters, Mono Lake* (detail)
 Bernard Steffen, *Haying* (detail)

CONTENTS

by Kevin M. Murphy

ACKNOWLEDGMENTS

ACKNOWLEDGMENTS

Neither this publication nor the exhibition would be possible without the philanthropy of Huntington supporters. First and foremost, we must thank Gary, Brenda, and Harrison Ruttenberg and Hannah S. Kully for inspiring this project by promising their print collections to the Huntington and for generously lending to the exhibition.

As the first book to take American prints in the Huntington Art Collections as its primary subject, this publication must acknowledge past directors Robert R. Wark and Edward Nygren, and curators Susan Danly and Amy Meyers, whose leadership helped establish and develop the permanent collection of American art.

Although this project focuses on prints made between 1905 and 1950, it provides a welcome occasion to honor the individuals and foundations who have donated American prints of all periods, or the funds to acquire American prints, to the Art Collections: E. Maurice Bloch; Edward W. and Julia B. Bodman; Dorothy Bowen; The Frances and Sidney Brody Charitable Fund; Mrs. Homer D. Crotty; Kelvin Lloyd Davis; Mrs. Alexander Evan; Judith and Stanley Farrar; Heather and Paul Haaga; Carol M. Jones; Margery and Maurice H. Katz; The Kruse Family Trust; Hannah and Russel Kully; The Ledler Foundation; Anthony and Edith Liu; Lee Lozowick, in memory of his father, Louis Lozowick; Elizabeth Medearis; Bradford and Christine Mishler; Hildegarde Flanner Monhoff; Grace Norman-Wilcox; Judith and Edward Nygren; Margaret Richards; Gary, Brenda, and Harrison Ruttenberg; The Virginia Steele Scott Foundation; Charles D. Seeberger; Mr. and Mrs. Clifford Silsby; John Steadman; Mary Ann and John Sturgeon; Ron Tank; Donald Treiman, in memory of his mother, Joyce Treiman; Mr. C. Edward Wall; Warren and Alyce Williamson; Mrs. Hamilton Wright; Deborah and Robert Wycoff; and Marcia and Donald Yust.

The success of the book and exhibition are, in large measure, due to the collective efforts of the Huntington's staff. Steven Koblik, President; John Murdoch, Hannah and Russel Kully Director of the Art Collections; and Roy Ritchie, W. M. Keck Foundation Director of Research championed the project at every juncture. Shelley Bennett, Elizabeth Clingerman, Jacqueline Dugas, Susan Hoffman, Alan Jutzi, and Brian Mains provided research and other critical support.

Gregg Bayne, along with Christian Mounger and Pat Pickett, helped create a beautiful exhibition and expertly oversaw the endless details involved in getting the works of art and informational text on the gallery walls. Carolyn Stuart, a doctoral candidate at

UCLA, took time away from work on her dissertation to help us edit the checklist and to generate critical research for the exhibition.

We are very grateful to Ed Marquand at Marquand Books, Seattle, Washington, for his interest in producing this book, and to his staff—particularly Zach Hooker for designing the publication and Adrian Lucia, Marie Weiler, and Brynn Warriner for coordinating the project. We also thank Martin Fox for editing and Sharon Rutberg and Cameron Allan for proofreading. At the Huntington Library Press, we would like to thank Peggy Park Bernal and Jean Patterson for supporting this project and coordinating the distribution of the book with the University of California Press. The Huntington's Department of Photographic Services, particularly Manuel Flores, John Sullivan, and Devonne Tice, provided the fine reproductions for the publication and all other printed materials associated with the exhibition.

My co-author, Kevin M. Murphy, the Bradford and Christine Mishler Curatorial Fellow in American Art, deserves to be singled out for his contributions to this project, which would not have been possible without his organization, enthusiasm, and intelligence. His positive attitude, inquisitive mind, and great aptitude for research and writing have been critical to the project's success.

This book and exhibition are made possible by a generous donation from the actor, author, and art collector Steve Martin, who provided the funds that made the project a reality.

Finally, a special word of gratitude is due to Hannah S. Kully, to whom this book is dedicated. Hannah and I began discussing this project in 2005, joined by Kevin Murphy in 2006. Over the course of the past two years, we have shared many stimulating and enjoyable hours of looking at and talking about American prints. With this book and exhibition, I hope we have succeeded in conveying some of the delight that we have shared in considering American prints and culture from the first half of the twentieth century.

Jessica Todd Smith
Virginia Steele Scott Curator of American Art

AMERICAN PRINTS AND THE HUNTINGTON ART COLLECTIONS

AMERICAN PRINTS AND THE HUNTINGTON ART COLLECTIONS

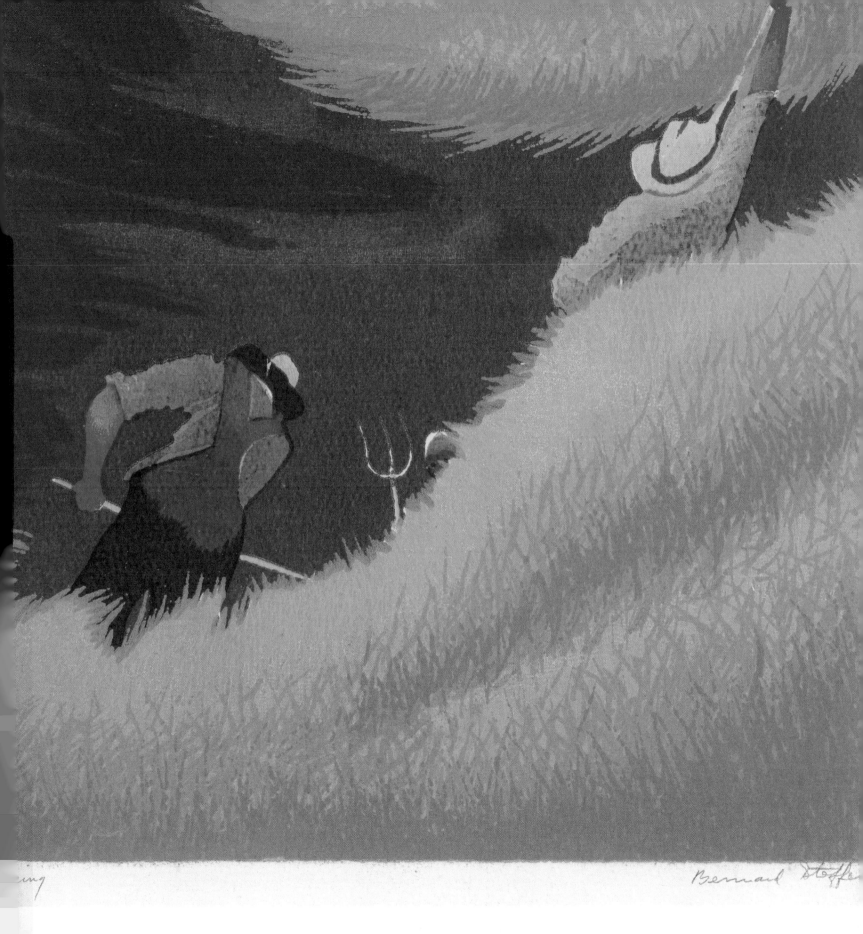

ing Bernard Stoffe

The Huntington Art Collections presently contain over a thousand American prints, approximately a third of which were created during the first half of the twentieth century. This portion of the print collection will be significantly enhanced in the future by two important promised gifts: the John Sloan collection of Gary, Brenda, and Harrison Ruttenberg and the American print collection of Hannah S. Kully. Both gifts were announced in 2005 and served as the inspiration for the exhibition *Pressed in Time: American Prints 1905–1950*.[1] The goals of this book, produced to accompany the exhibition, are to bring the strength of our American print collection to the public's attention, to celebrate the vision of its donors, and to inspire further scholarship on and research into this part of the Huntington Art Collections.

Since the Ruttenbergs and Hannah Kully are still very much engaged in developing and refining their respective collections, a comprehensive catalogue of the American Print Collection at the Huntington seemed premature. Nor did it feel appropriate at this juncture to attempt a survey of the field as represented here. Instead, we have chosen a selection of prints that represents a synergy between subject and technique, between the diverse themes that captured the attention of artists working in the first half of the twentieth century and the distinctive formal qualities that printmaking allowed them to achieve.

In organizing the exhibition, we adopted what I would like to call a "conversational premise." After reviewing the Huntington, Ruttenberg, and Kully collections, we developed a checklist of what we felt were some of the most visually striking images, featuring the most interesting content and representing a variety of intaglio, relief, and planographic print techniques (described in the glossary). From this list, we looked at how the prints "conversed," separating them for organizational purposes into four large categories: urban places, urban people, rural places, and rural people. We then divided those large designations into smaller groups of prints that

seemed to speak to one another, reflecting how various artists addressed subjects in different ways and, on occasion, how a single artist addressed a theme. We took great delight in allowing formal preferences to influence our selections on some occasions and permitting an interest in subject to dominate in others. The end result, we hope, is a selection of work that inspires the close looking and thoughtful analysis that prints demand and deserve. The complete checklist appears at the end of this volume, with highlights explicated by curatorial fellow Kevin M. Murphy in the section of plates following this introduction.

Prints in America, 1905–1950

The first decades of the twentieth century witnessed the creation of art with a greater variety of subject and style than the world had ever seen. As photomechanical reproductive techniques took hold in the commercial printing industry, there was less demand for artists to create imagery for newspapers and illustrated periodicals. A number of artists who had begun their careers as newspaper illustrators moved away from the literalism demanded by journalism while adopting the people and places of the city as their primary subject in prints as well as paintings. Their work is deeply imbued with political and social engagement, but is free from the direct connection to text that characterizes the illustrative tradition from which it emerged. At the same time, printmakers began to explore modernist aesthetics, particularly after the Armory Show of 1913. A part of Franklin Delano Roosevelt's New Deal, the Federal Art Project of the Works Progress Administration supported printmaking as a less costly way to make art accessible to more people than painting or sculpture. Overall, the era marked great changes in the visual arts, and prints in particular recorded and reflected concurrent shifts in social and cultural behavior.

Dramatic transformations in all aspects of everyday life paralleled the expansion and diversity in the

visual arts, with some of the most striking changes taking place in major cities. The rapidly developing urban landscape was the setting for new building forms and entertainments—skyscrapers, movies, and amusement parks, to name a few—and provided a new variety of places for people to work, play, and interact. Artists also found subjects of interest in life outside of the city—small towns, farm communities, industrial and agrarian landscapes and livelihoods. The consequences of economic depression and the changing face of labor affected people across the nation in the 1930s and early '40s, and were addressed by artists in their work. Sometimes these images reflect deep pessimism about the ability of capitalism to produce social justice, and sometimes they demonstrate a heroic view of industry and an idealized view of life in the nation's agrarian heartlands. Similarly, the World Wars had a multifaceted impact on the entire country. Throughout this tumultuous period, printmaking served as a cost-effective form of artistic expression and means of communicating artists' observations and ideas.

American Prints at The Huntington

Henry E. Huntington acquired great quantities of material relating to American history—books, prints, photographs, and manuscripts. He bought American portraits and sculpture either for their historical significance or for decorative purposes, and he acquired a few important paintings by American artists who fit within the parameters of the collection of eighteenth-century British art that he built with his wife Arabella. To this day, there are many American prints in the Library Collections in the form of book illustrations, extra-illustrated books, historical prints, maps, and printed ephemera such as posters, trade cards, and fruit-crate labels. This portion of the Huntington's collections, while of great interest and scholarly value, was not specifically considered for this project, which is concerned with printmaking as a form of art, related to illustration, but distinct in terms of its

purpose and the nature of its formal language in the twentieth century.

Two of the earliest gifts to the Huntington that included American prints now part of the Art Collections were the Bodman Collection donated in 1941 and the Seeberger Collection donated in 1972. Both of these gifts were initially accessioned into the Library but transferred to the Art Collections when the Print Room was established in the 1980s.

The Virginia Steele Scott Foundation

The founding of a distinct Department of American Art within the Huntington Art Collections can be credited to the Virginia Steele Scott Foundation. Virginia Steele Scott (1905–1975) was a Pasadena collector passionate about the educative powers of art. Wanting to share her own, somewhat eclectic, collection with the public, she built a free-standing gallery on her Pasadena property, but zoning restrictions prevented her from opening the building to the audience she had hoped. In 1974, she created the Virginia Steele Scott Foundation and, after her death in 1975, the Foundation began collecting American paintings, with the goal of donating them to an institution that would exhibit them in her honor. The Foundation, after much deliberation, eventually decided on the Huntington as an appropriate recipient of the collection it had amassed. It also provided the funds to build the Virginia Steele Scott Gallery of American Art, which opened to the public in 1984. Eventually, the Foundation sold Scott's Pasadena home and most of her art collection, although a number of American prints that she had owned were given to the Huntington—one by Mary Cassatt, forty-six by Arthur Henry Thomas Millier (fig. 1), and sixteen by Childe Hassam, including *The White Kimono* (pl. 31).

The first art advisor on the Scott Foundation's board was Millard Sheets (1907–1989). His term was followed by Professor E. Maurice Bloch (1916–1989), an art historian who taught at University of California, Los Angeles. Bloch gave three prints to the

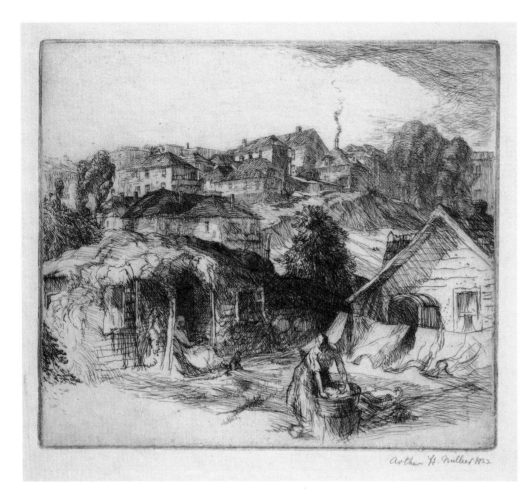

Fig. 1 Arthur Henry Thomas Millier, *Monday Morning (Bunker Hill, Los Angeles)*, 1922, etching

collection during his lifetime. Although he had intended to donate his own large collection of works on paper, he died intestate and the collection went to auction in 1991. Funds from the Scott Foundation were used to acquire a selection of prints and drawings from the sale. Another important addition was made in 1991 when Mrs. Homer D. Crotty donated 121 American prints, including a significant group of wood engravings by Paul Landacre.

Although successive curators have added important prints by purchase, the collection has grown predominantly thanks to generous gifts by many individual enthusiasts who are listed in the acknowledgments. Preeminent among these in relation to this exhibition have been the Kruse Family Trust, which donated a complete collection of prints by Alexander Kruse, and Margery and Maurice H. Katz, who not only have contributed to the collection but

who, through their tireless enthusiasm, have inspired others to follow suit.

The John Sloan Collection of Gary, Brenda, and Harrison Ruttenberg

Gary, Brenda, and Harrison Ruttenberg have begun giving their extensive John Sloan Collection, which presently consists of approximately 50 drawings, 350 prints, various illustrated books, illustrated magazines, and ephemera. The gift, pledged to come over a number of years, eventually will make the Huntington the greatest center for the study of John Sloan apart from the Philadelphia Museum of Art in Pennsylvania and the Delaware Museum of Art in Wilmington, Delaware, where the Helen Farr Sloan Library serves as the home of the John Sloan Manuscript Archive.

When the Ruttenbergs began collecting art in the late 1960s and early 1970s, they bought prints by German Expressionist artists and other modern masters. After an unfavorable shift in the exchange rate, the prints that they desired cost more than the young couple wished to invest. They increasingly gravitated toward American art inspired, in part, by the people who came to surround them. Gary Ruttenberg has noted an efflorescence of interest in American art in the late 1960s, pioneered by a group of collectors in the Los Angeles area and professional art historians who shared their knowledge and passions. The Ruttenbergs joined the Graphic Arts Council at the Los Angeles County Museum of Art in 1969 and the American Art Council after it was established in 1973. "From that point on," the Ruttenbergs describe, "we experimented as young collectors, floating in and out of different areas of interest, but always stayed with American art."

Early twentieth-century American prints appealed to the Ruttenbergs as a sort of counterpart to the prints made by the Fauves in France and the group known as Die Brücke in Germany. All three movements were defined by young artists going out, looking at people, and reacting to early twentieth-century

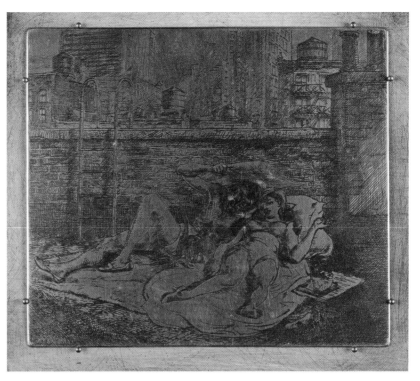

culture in their work. The American artist who particularly appealed to the Ruttenbergs was John Sloan (1871–1951), who began his career as a newspaper staff artist and later drew upon his observations of everyday life as the subjects for his prints and paintings. The Ruttenbergs found themselves drawn to the social and political content apparent in much of the artist's work, and they were specifically inspired by a John Sloan exhibition held by the National Gallery of Art, Washington, D.C., in the fall of 1971. Several months later, the first Sloan print entered their collection. Gary purchased the lithograph *Sixth Avenue and Thirtieth Street* in January 1972 as a present for Brenda upon her graduation from law school, and she fell in love with the piece. The next month, they bought their second Sloan print, and their collecting continued from there. Through their enthusiasm for Sloan's work, they came to meet the artist's widow, Helen Farr Sloan (1911–2005), who became a friend of the family and encouraged their collecting. The Ruttenbergs gradually amassed a comprehensive body of the artist's work, including paintings, drawings, multiple states and impressions of various

prints and, in the case of *Sunbathers on the Roof* (fig. 2), the etching plate used to make the print (fig. 3).

The American Print Collection of Hannah S. Kully

The American print collection of Hannah S. Kully includes some of the most striking prints made in the first half of the twentieth century—both iconic images and work by artists that one does not commonly see. If the Ruttenbergs' philosophy toward John Sloan's oeuvre represents a "vertical" approach to collecting, focusing on one artist in great depth, one might describe Hannah Kully's collection as "horizontal," for it consists of approximately three hundred important American prints by nearly a hundred different artists working during the first half of the twentieth century. She set parameters for her acquisitions after having collected for about ten years, when she realized that most of her prints were made between the two World Wars. At first she considered only black-and-white images, but she has come to include color prints in recent years. As an overall philosophy, she places prints of first-rate

Fig. 2 John Sloan, *Sunbathers on the Roof*, 1941, etching

Fig. 3 John Sloan, *Sunbathers on the Roof*, 1941, gold-plated copper etching plate

quality as a higher priority than works by artists with the most recognizable names, though her collection certainly includes those as well.

When Hannah Kully began collecting, she was looking at late-nineteenth-century European genre prints before quickly gravitating toward twentieth-century American prints. The first American impression she acquired was Isabel Bishop's *Snack Bar*, which she bought in 1977. Some years passed before she began to collect American prints in earnest. In 1985, she made three key acquisitions, *January* by Grant Wood (fig. 4), and *Wreck of the Ol' 97* and *The Race* by Thomas Hart Benton. She bought a number

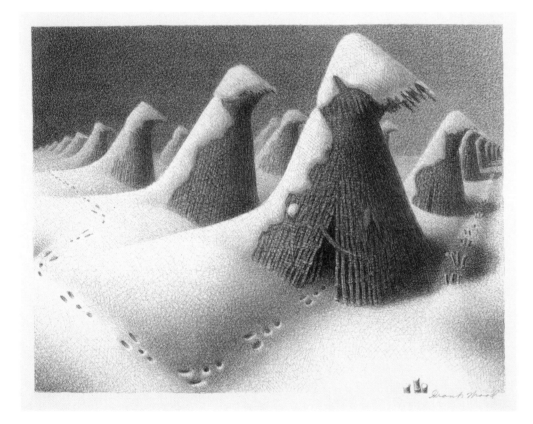

of prints from Jake Zeitlin's Los Angeles gallery as it was closing in 1986, and her collecting intensified as she began attending print fairs and visiting knowledgeable dealers. She has been much encouraged by her husband, Russel I. Kully, who donated his collection of British prints to the Huntington in 1994 and continues to share his enthusiasm for the medium.

In 1999, after building her collection for over a decade, Hannah Kully curated a selection of the work in the exhibition *The Pleasure of Prints: American Graphics 1914–1951* for the Gallery at 777 in downtown Los Angeles. She recounts how it was in thinking about the exhibition that she came to discover why she was drawn to American prints of this era. At the time, she was earning her Ph.D. in sociology from UCLA, and she realized that the subjects of the prints she was collecting were related to her studies in cultural sociology. The artists were "trying to discuss what being American was all about . . . trying to find the meaning of America and where its values lie." She also observed that she was on the right track with the European prints she had first approached, but she felt more engaged with American subjects, claiming "I could identify more with American imagery—I could recognize the people and places, their practices, beliefs, and rituals." She and Russel had begun studying and acquiring prints some twenty years prior to the start of her own collection, so she knew what technical qualities constituted a good print, but she became increasingly interested in issues of design and iconography. While she admits that she sometimes is driven to acquire a piece by her interest in its historical content, she particularly appreciates prints in which the medium and message come together to make a strong, unified statement as, for example, in Paul Landacre's *Coachella Valley* (fig. 5) where solid dark forms evoke imposing mountains that overshadow the train running across their base. A beautiful impression in perfect condition, the wood engraving captures the California landscape in a way that is historically specific and graphically striking.

While the majority of Hannah Kully's acquisitions have been made through thoughtful, intellectual decisions, others have been made, in her words, "just for fun," reflecting her wit and warm sense of humor. Her fascination with artists who were exploring the meaning of America through prints still holds as she has continued to build her collection,

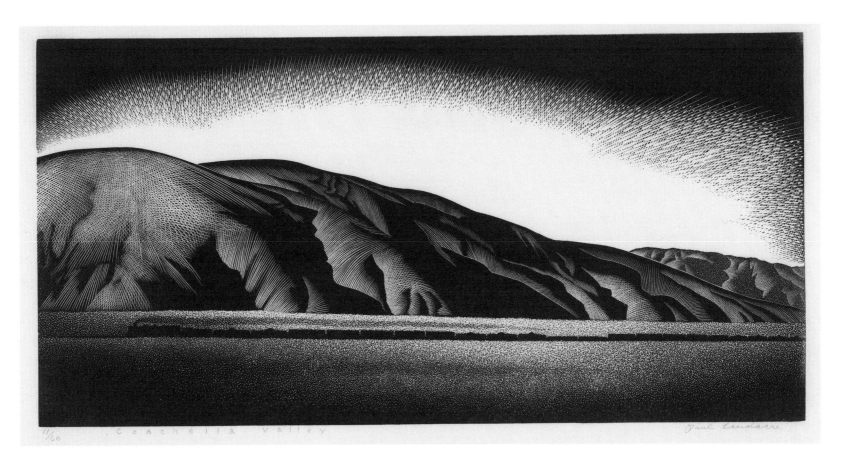

Fig. 5 Paul Landacre, *Coachella Valley*, ca. 1935, wood engraving

generously lending to the exhibition and contributing her ideas to this project.

Conclusion

One of the greatest challenges in making the selection of images from the Huntington, Ruttenberg, and Kully collections to be included in *Pressed in Time: American Prints 1905–1950* was deciding what material had to be excluded, and omitting the work of some artists entirely, on account of space constraints. From our perspective at this moment in the twenty-first century, we have selected prints that seem to capture the spirit of a certain cultural frisson that took place in art and culture of the United States during the first half of the twentieth century, grouping the works so that they are "in conversation" with one another and, we hope, the viewer in the gallery and the reader of this book. Looking ahead to the future, other people will use the American prints in the Huntington Art Collections to make alternate selections and to raise different issues about the history of art and society. This promise is exactly what makes a print collection exciting, important, and worth the space, time, and energy of us all.

ENVISIONING THE CITY

American printmakers began representing the city during the nineteenth century, but the pace of urban images quickened along with the tempo of urban life around 1920 when, for the first time in America, more people lived in cities than in rural areas.[1] Artists found the city fascinating for its aesthetic and symbolic qualities, echoing F. Scott Fitzgerald's pronouncement that New York in the 1920s "had all the iridescence of the beginning of the world."[2]

The skyscraper, which became linked to national power and discussed as a native form of American architecture, emerged as a prime subject for artists. During the 1930s, skyscrapers proliferated in New York, as architects and their patrons competed to construct the world's tallest building. The iconic Chrysler Building and 40 Wall Street were completed in 1930; the Empire State Building, Waldorf-Astoria Hotel, and City Bank-Farmer's Trust Building in 1931; the American International Building in 1932; and the RCA Building in 1933.

Artists often presented the city from an elevated point of view, influenced by New York's race to the sky and their own experience in skyscrapers. Howard Norton Cook's *Harbor Skyline* (pl. 1) provides a panoramic view of New York from the perspective of an immigrant approaching for the first time. In Adolf Dehn's *Central Park at Night* (pl. 2) the viewer is distanced from skyscrapers along Fifth Avenue by the pastoral expanse of the park, perhaps revealing an aspect of Dehn's experience as a transplant from rural Minnesota.

Armin Landeck and John Taylor Arms trained as architects, which provided them with a deep understanding of the structure of buildings. Arms's *West Forty-Second Street, Night* (pl. 3) and Landeck's *Manhattan Vista* (pl. 5) share precise draftsmanship. Arms used the tonal range of aquatint to convey the atmospheric effects of electric light. Landeck created an abstract geometric pattern by depicting buildings from an acute downward angle, demonstrating the influence of the Precisionist aesthetic on his work. Samuel Margolies's *Man's Canyons* (pl. 6), features two additional characteristics of Precisionism: diagonal lines cutting through the image and the reduction of forms to their essential qualities. These devices provide a sense of dynamic movement in an image that includes the Chrysler Building and the Empire State Building.

Many prints portrayed the city in a positive, even heroic, light; but the city also held sinister connotations. Boris Artzybasheff's *The Last Trumpet* (pl. 7) illustrates anxieties about American urban spaces during the Depression, when some cultural critics believed that America's economic and social problems stemmed from the decadence of American cities, particularly New York.

Note 1 United States Department of Commerce, Bureau of the Census, *Historical Statistics of the United States, Colonial Times to 1970,* "Population in Urban and Rural Territory, by Size of Place: 1790–1970," Series A 57–72, (Washington, D.C.: U.S. Government Printing Office, 1975), 11–12.

Note 2 F. Scott Fitzgerald, "My Lost City," in *The Crack-Up,* ed. Edmund Wilson (New York: J. Laughlin, 1945), 25.

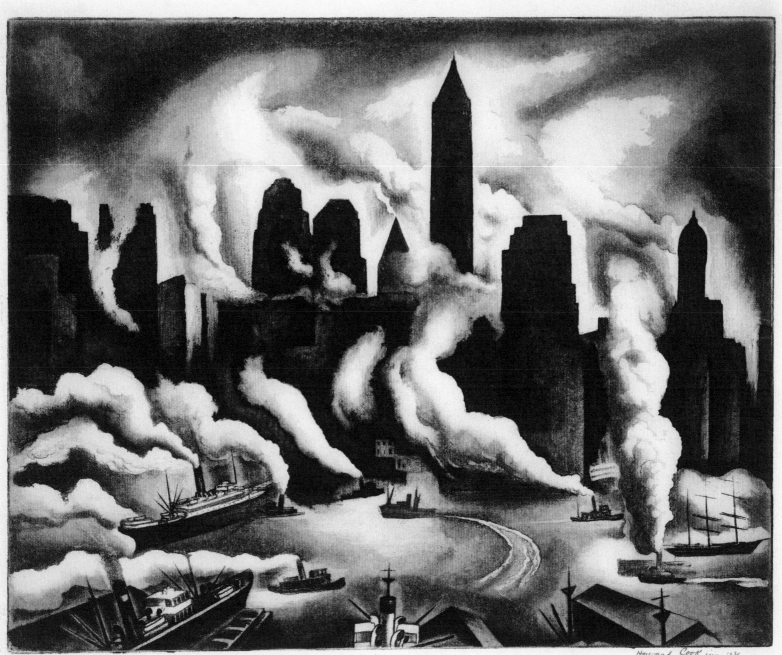

1. Howard Norton Cook Harbor Skyline, 1930 soft-ground etching and aquatint

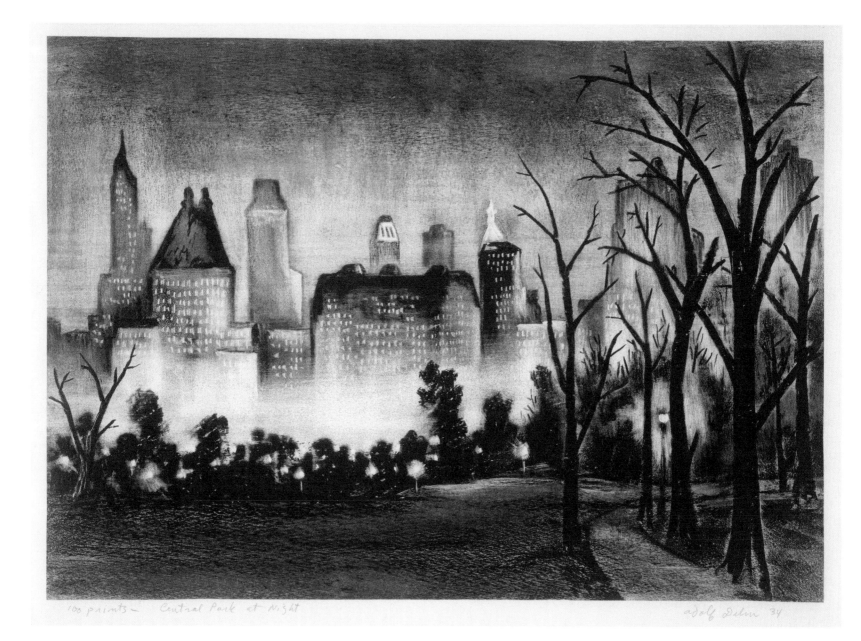

100 prints — Central Park at Night adolf Dehn 34

2. Adolf Dehn Central Park at Night, 1934 lithograph

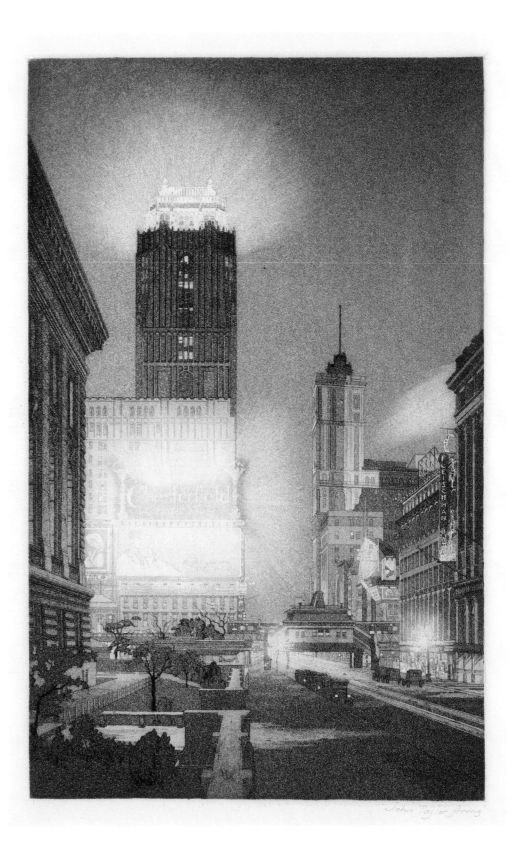

3. John Taylor Arms West Forty-Second Street, Night, 1922 etching and aquatint

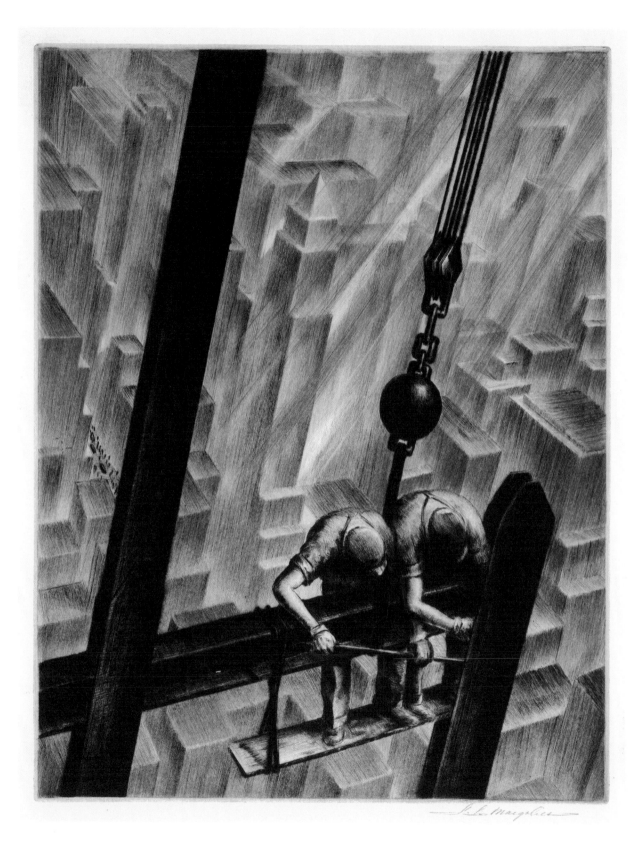

4. Samuel Margolies Men of Steel, ca. 1940 drypoint

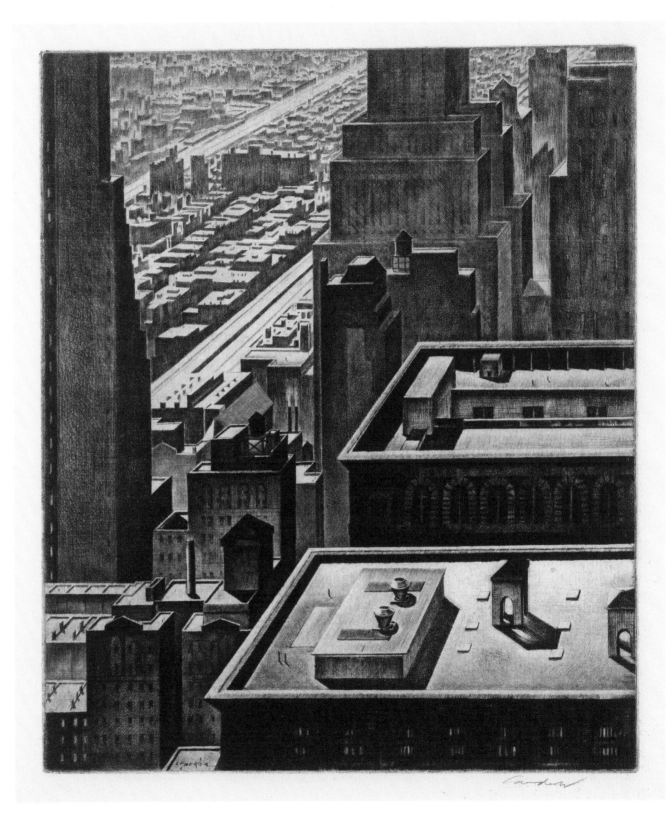

5. Armin Landeck Manhattan Vista, 1934 drypoint

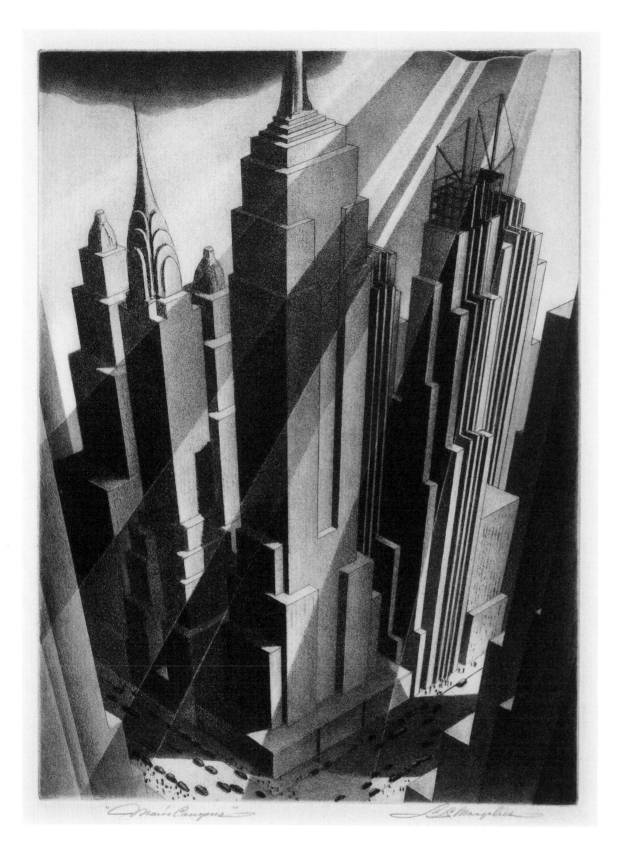

6. Samuel Margolies Man's Canyons, 1936 etching and aquatint

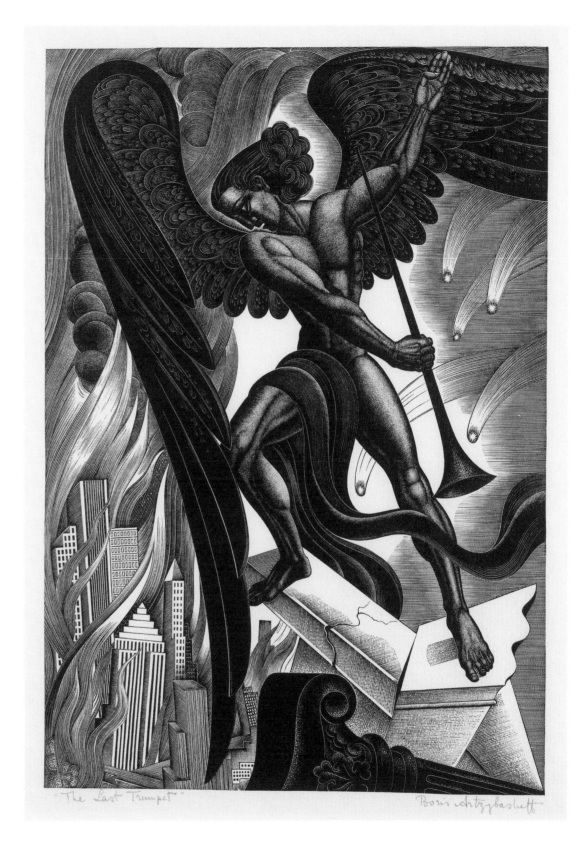

7. Boris Artzybasheff The Last Trumpet, 1937 wood engraving

THE MOOD AND ATMOSPHERE OF THE CITY

Martin Lewis and Edward Hopper were more intrigued by the atmospheric conditions created by electric light or snow swirling through city streets than they were by the specific forms of urban architecture. Martin Lewis instructed his friend Edward Hopper in etching technique, and both artists produced moody images of the city. Lewis's work tended to be about atmosphere rather than narrative, whereas Hopper's reductive compositions suggested the isolation possible even within a city teeming with people.

In *Glow in the City* (pl. 8) Lewis created ambiance by contrasting the bright tower of the Chanin Building—the lights of which could reportedly be seen for up to thirty-five miles—to darkened tenement houses.[1] He produced the print's remarkable atmospheric effects by varying the density, direction, and depth of lines he scratched into its plate with his drypoint needle. The woman with fashionably bobbed hair who gazes longingly toward the Art Deco building links two otherwise disparate worlds found on the island of Manhattan: the tenement and the skyscraper. In *Stoops in Snow* (pl. 9), Lewis turned his attention away from man-made conditions to study the intrusion of nature into city life.

Edward Hopper's *Night Shadows* (pl. 10) shares with *Glow in the City* a focus on artificial light: Lewis created subtle transitions between light and dark, while Hopper's expressive handling of the etching needle produced stark contrasts. Hopper also placed the viewer above the street, looking down on the lone figure, rather than at the level of his subject, as Lewis did. This disconcerting angle, the oppressive shadows, and unresolved narrative lend a mysterious aura to the scene.

Hopper produced the first edition of *Night Shadows* in 1921, but a subsequent edition was made in 1924 as part of a promotional offer by *The New Republic* magazine through which subscribers received a year's subscription to the magazine and six etchings, all for $9. The other artists in the portfolio were John Sloan, Peggy Bacon, John Marin, Kenneth Hayes Miller, and Ernest Haskell. Throughout the early twentieth century, American printmakers attempted to increase their visibility and sales through innovative marketing strategies, such as including their prints with magazine subscriptions. In 1913 John Sloan took out an advertisement in *The Masses* offering etchings from his *New York City Life* series for $2 apiece with a $1 magazine subscription.

Note 1 According to a promotional brochure, lights in the tower put out thirty million candlepower. Quoted in Paul McCarron, *The Prints of Martin Lewis: A Catalogue Raisonné,* (Bronxville, NY: M. Hausberg, 1995), 142.

8. Martin Lewis Glow in the City, 1929 drypoint

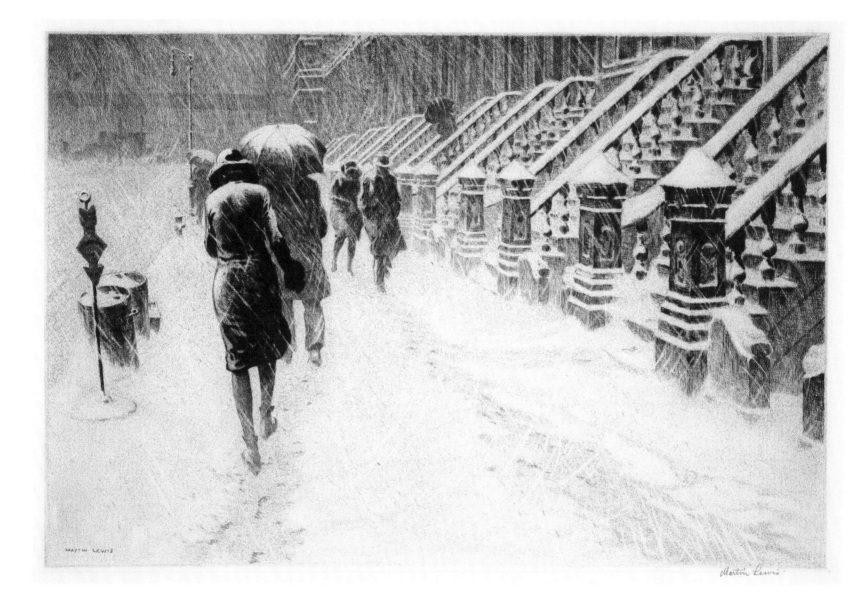

9. Martin Lewis Stoops in Snow, 1930 drypoint and sand-ground etching

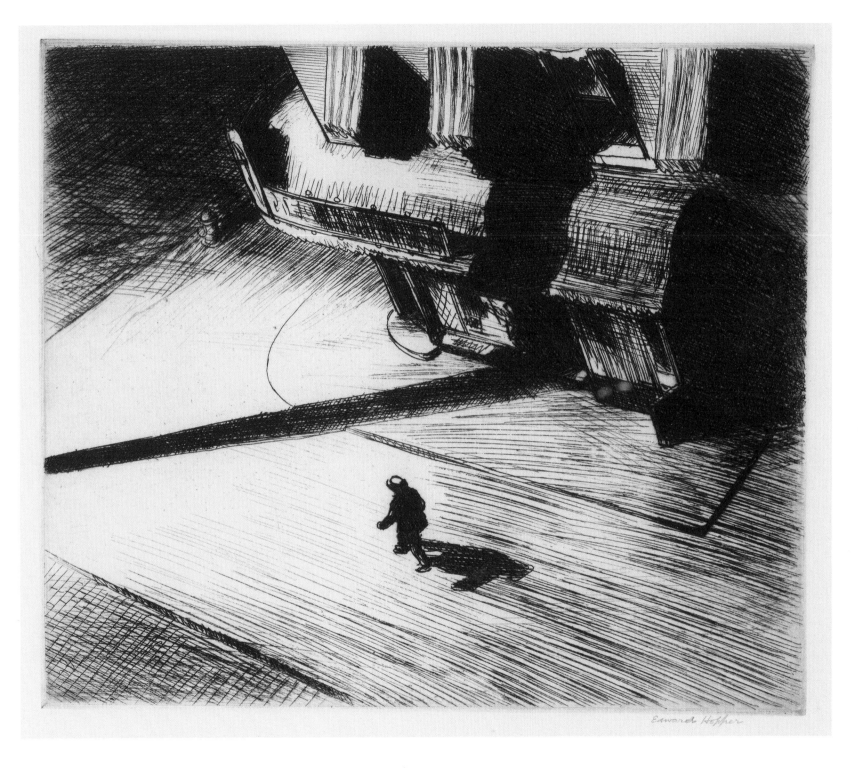

10. Edward Hopper Night Shadows, 1921/1924 etching

PUBLIC LIFE AND ENTERTAINMENT IN THE CITY

While some artists were attracted to the architecture and atmosphere of the city, others concentrated on its inhabitants, depicting the blurring of distinctions between public and private life that occurred in New York's crowded spaces. The prints in this section show printmakers' attraction to modern entertainment: prize fights, the movies, night clubs, and Coney Island.

John Sloan and George Bellows were influenced by their teacher Robert Henri, who urged his students to make art based on their experience of life in the city. Critics labeled Henri's circle the "Ashcan School" because their works often featured gritty streets populated by the lower classes, and were created using a loose, anti-academic technique. Sloan's and Bellows's experience as newspaper and magazine illustrators aided their ability to capture fleeting incidents of urban life.

In *Barber Shop* (pl. 11), Sloan brought contemporary culture into a traditional, masculine space with the inclusion of the socialist magazine *The Masses*, to which he and Bellows were contributors, along with the satirical weekly *Puck*. In *Fun, One Cent* (pl. 12), Sloan explored the possibilities for voyeurism in the city. He "garnered this bouquet of laughing girls" at a nickelodeon, which showed an early form of motion pictures.[1] By 1928, when Mabel Dwight produced her humorous lithograph, *The Clinch* (pl. 13), movie theaters had replaced the nickelodeon.

Like Sloan's prints, George Bellows's *A Stag at Sharkey's* (pl. 14) and *Preliminaries* (pl. 15) address social transformations around issues of gender. *A Stag at Sharkey's*, based on a painting from 1909 (Cleveland Museum of Art), focuses on the brutality of boxing performed in front of an exclusively male, working-class crowd. Bellows brought the viewer inside the ring by barely suggesting ropes in the foreground, almost eliminating a sense of enclosure. *A Stag at Sharkey's* represents a time when prize fighting was illegal in New York, but thrived underground in seedy bars like Tom Sharkey's Athletic Club. In contrast, *Preliminaries* shows boxing as somewhat tamed and made into entertainment for genteel spectators, in part because of the presence of women in the audience. The lithograph is based on a drawing of a legal bout held at Madison Square Garden to which women were admitted for the first time.[2] Bellows focused on the crowd in evening dress, particularly a lithe young woman who turns toward the viewer and assertively returns our gaze. The inherent violence of boxing has been mitigated by moving the fight to the background and completely enclosing the ring, separating it emphatically from spectators and the viewer.

Miguel Covarrubias's *The Lindy Hop* (pl. 17) conveys vibrant Harlem nightlife through its repeated pattern of sinuous dancers. Covarrubias came to the United States from Mexico in 1923 and became a caricaturist for *Vanity Fair*. He was introduced to the efflorescence of art, literature, music, and poetry coming out of Harlem in the 1920s, and contributed illustrations to *The New Negro, An Interpretation*, the seminal text of the Harlem Renaissance edited by Alain Locke. The lithograph's title refers to a dance invented in Harlem during the 1920s that was particularly associated with African-American culture.

Note 1 John Sloan, quoted in Peter Morse, *John Sloan's Prints: A Catalogue Raisonné of the Etchings, Lithographs, and Posters* (New Haven, CT, and London: Yale University Press, 1969), 131.

Note 2 "The Passing Shows," *Art News* 41 (October 1–14, 1942), 27.

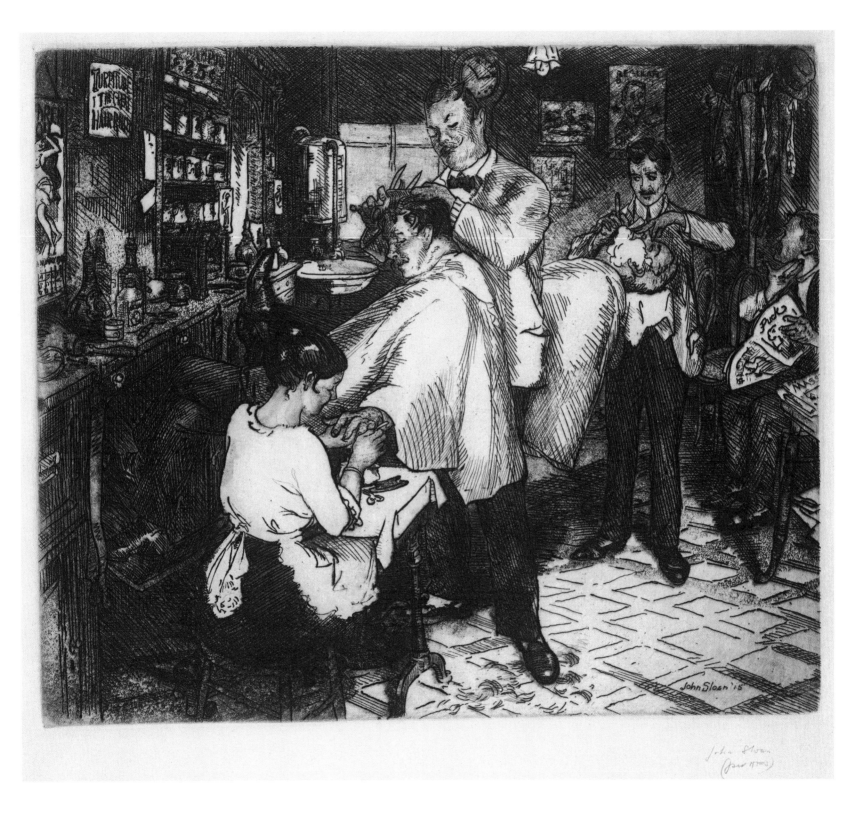

11. John Sloan Barber Shop, 1915 etching and aquatint

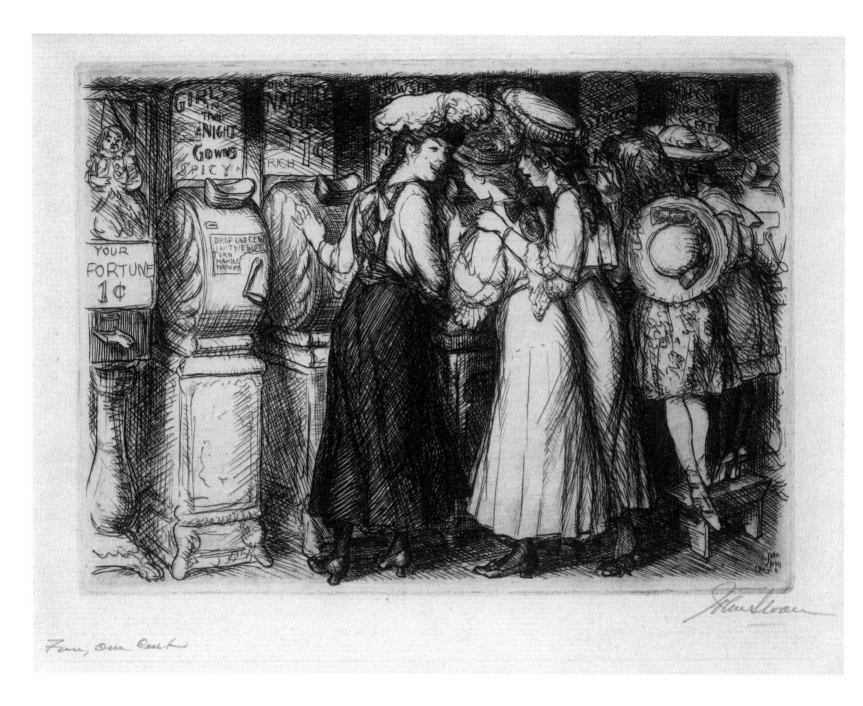

Fun, One Cent

12. John Sloan Fun, One Cent, 1905 etching

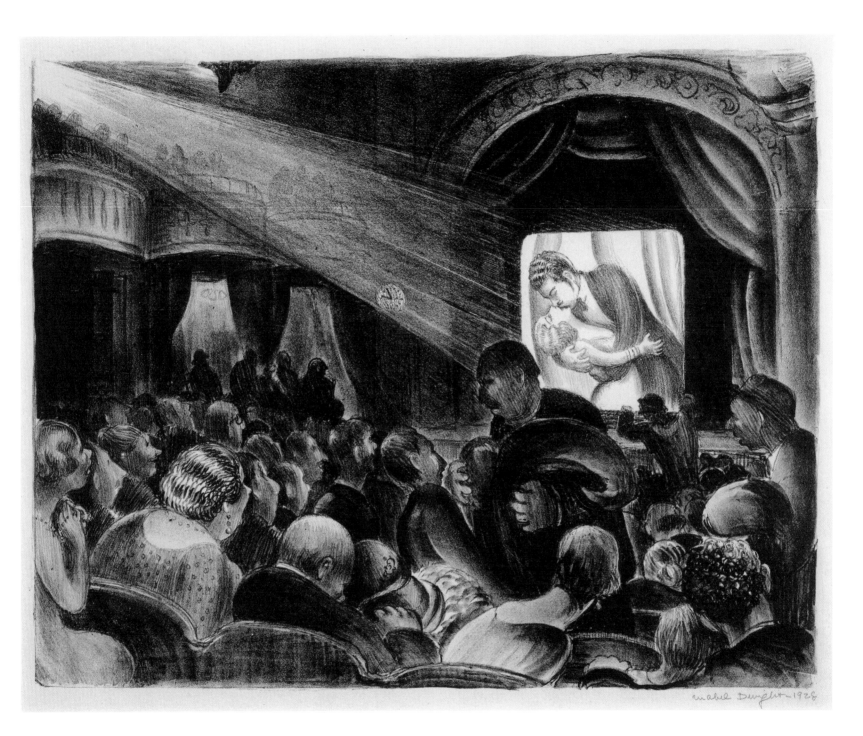

13. Mabel Dwight The Clinch, 1928 lithograph

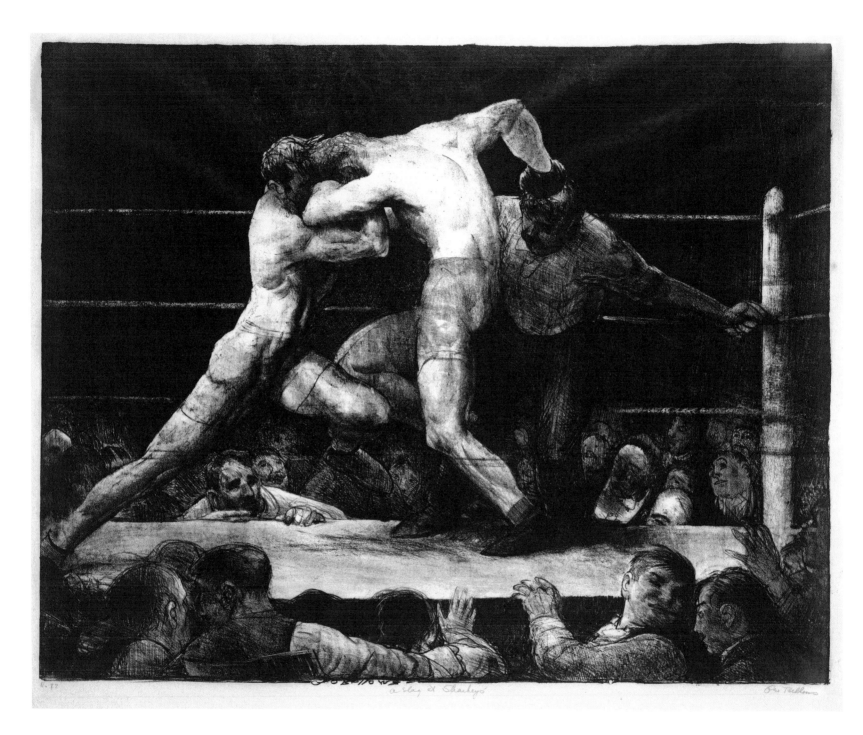

14. George Wesley Bellows A Stag at Sharkey's, 1917 lithograph

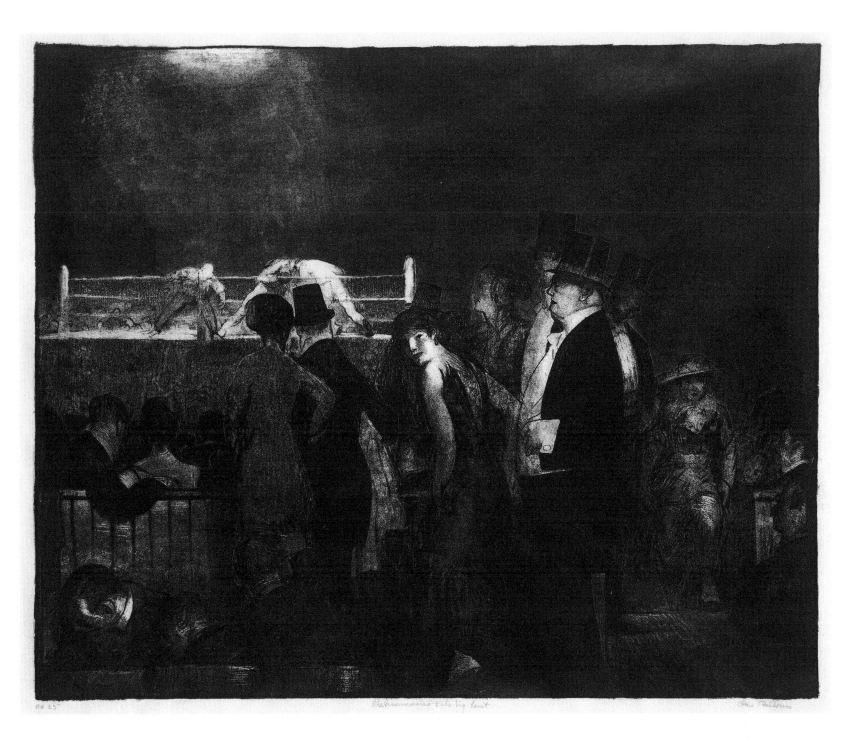

15. George Wesley Bellows Preliminaries, 1916 lithograph

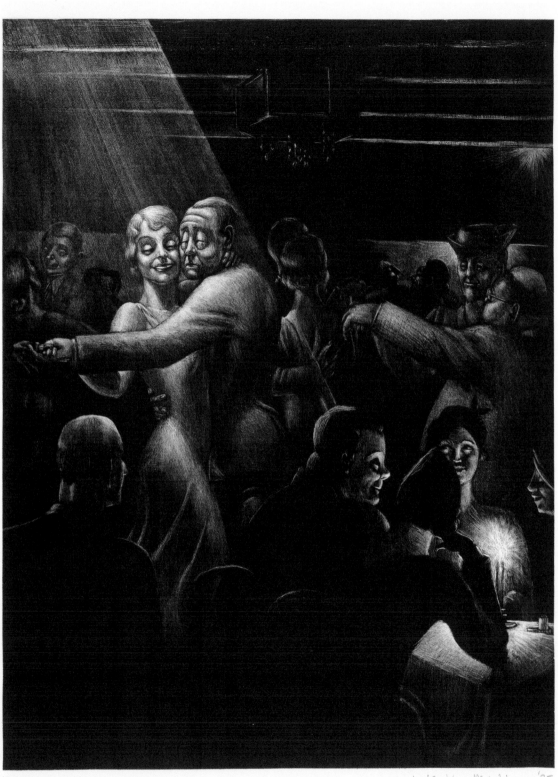

"Night Club" 1-16 Kyra Markham '35

16. Kyra Markham Night Club, 1935 lithograph

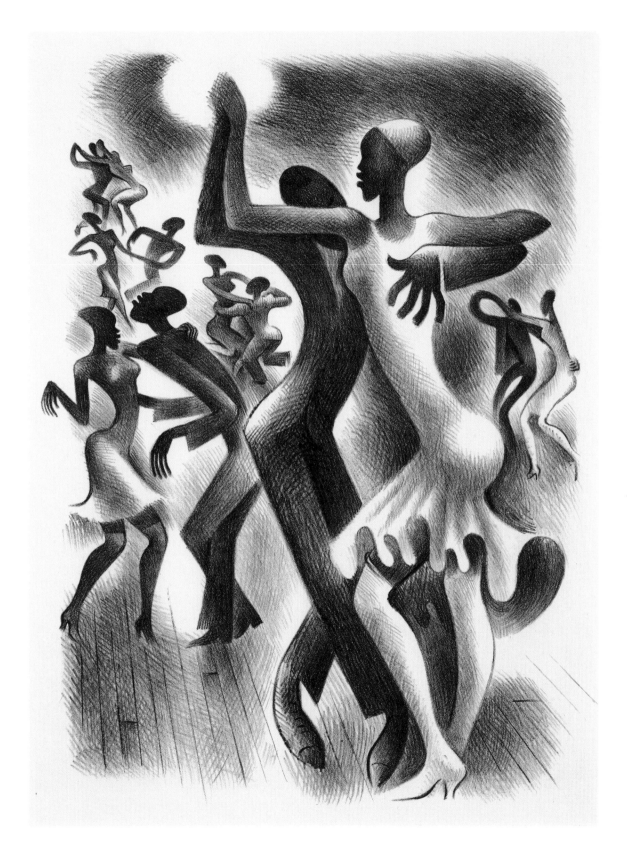

17. Miguel Covarrubias The Lindy Hop, 1936 lithograph

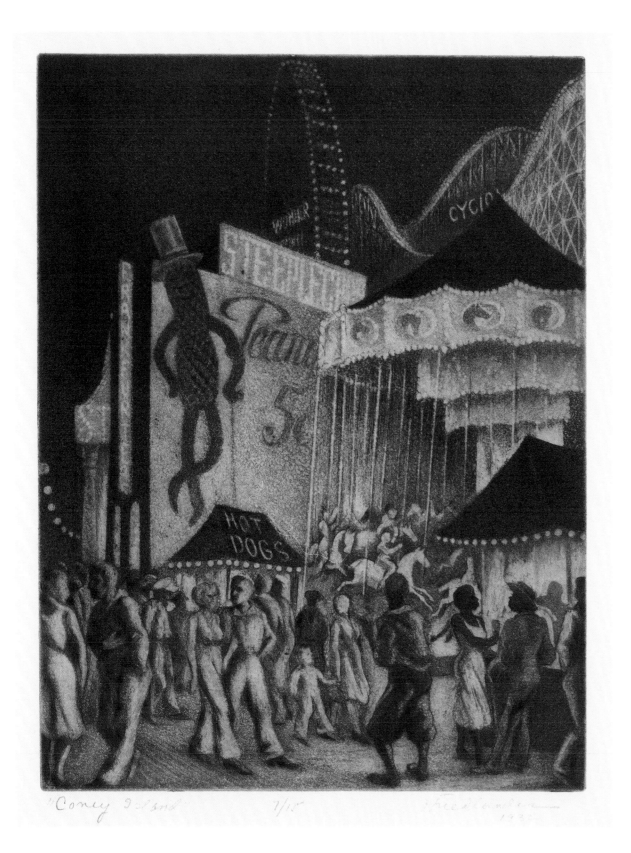

"Coney Island" 7/15 Friedlander
 1932

18. Isaac Friedlander Coney Island, 1932 etching and aquatint

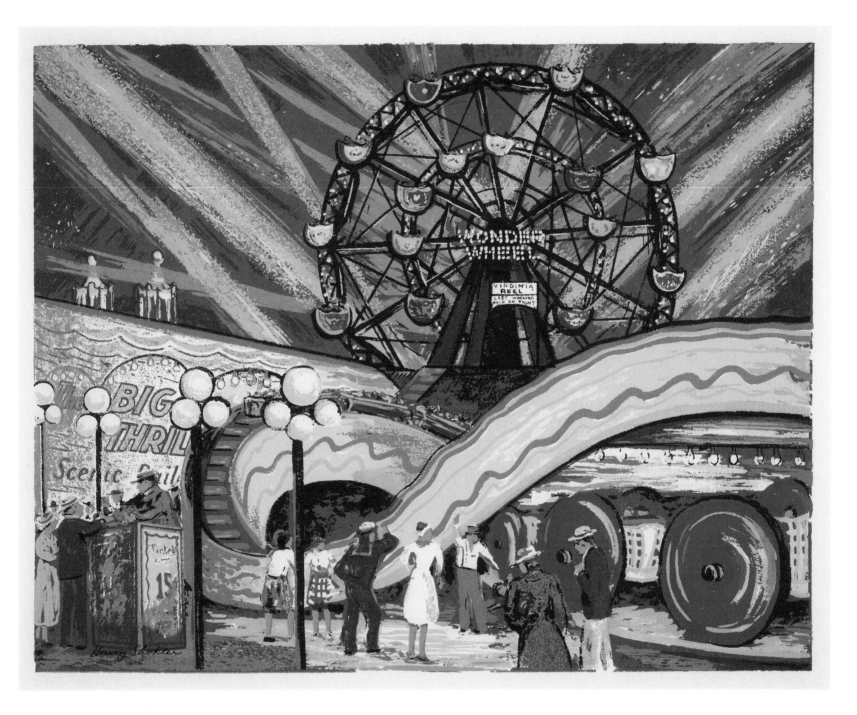

19. Harry Shokler Coney Island, ca. 1940 color screenprint

PUBLIC TRANSPORTATION AND LABOR

Along with depictions of leisure, printmakers addressed Americans at work and the subway, elevated trains, and trams that urban workers took to get there, often choosing woodcut or wood engraving as their medium. Fritz Eichenberg called woodblock prints "the most democratic medium of art. Whatever the social, political, or religious significance may have been, it has always been the carrier of a message."[1] This history, relative ease, and speed of producing woodcuts or wood engravings made them appropriate for artists who focused on contemporary society.

Charles Turzak's woodcut *Man with Drill* (pl. 20) was influenced by the Italian Futurists, who believed that the essential characteristic of modernity was speed. Futurists outlined objects with series of concentric lines to express movement, like those Turzak placed around his worker and drill to make visible the vibration caused by the tool. Turzak extended the effects of the drill to the buildings in the background, as though construction shook the entire city.

Fritz Eichenberg, like Sloan and Bellows, captured quotidian aspects of city life. He created the wood engraving *Subway* (pl. 21) because he "was enchanted even by the grimy Dantesque subway with its passengers composed of all the voices of the earth."[2] Eichenberg emphasized the weariness of the train's passengers by contrasting them with the lively advertisements promising romance.[3] Ida Abelman also presented the subway as a hellish place where people were shoved into cars. Like Eichenberg she employed irony, titling her dreary, surrealistic image *Wonders of Our Time* (pl. 22).

Donato Rico's *Bystander* (pl. 24) poignantly contrasts those who found work during the Depression with those who did not. The title indicates that our sympathy should lie with the downtrodden figures in the background, rather than the workers. By contrast, Leon Bibel and Michael J. Gallagher directed sympathy toward the worker. Bibel used the expressive power of color to illustrate the unhealthy conditions miners encountered underground, while Gallagher depicted miners at the end of the day, their bodies bent by toil. Bibel's *Descending* (pl. 25) was created with a color screenprint process, which increasingly became the most commonly used medium for Social Realist printmaking. Color screenprinting had been almost exclusively used for commercial purposes until printmakers in the 1930s realized that the simplicity of the technique and the power of color could be harnessed to make fine-art prints that addressed social issues.

Gallagher, Bibel, Rico, Abelman, and Eichenberg worked for the Federal Art Project of the Works Progress Administration during the Depression, which paid them a salary to produce art. It is no coincidence that these artists found sympathy with laborers during their time in the WPA/FAP, when they too worked for meager wages. Many of the printmakers associated with the WPA/FAP were involved in socialist causes, influencing their choice to highlight the sorry plight of the working classes.

Note 1 Fritz Eichenberg, "Eulogy on the Woodblock," in *Art for the Millions: Essays from the 1930s by Artists and Administration of the WPA Federal Art Project*, ed. Francis V. O'Connor (Boston: New York Graphic Society, 1973), 148.

Note 2 Letter from Fritz Eichenberg to Ellen Ekedal in Ellen Ekedal, et. al., *Spirit of the City, American Urban Painting, Prints and Drawings 1900–1952* (Los Angeles: Loyola Marymount University, 1986), 22.

Note 3 Bruce Robertson, *Representing America: The Ken Trevey Collection of American Realist Prints* (Santa Barbara: University Art Museum, University of California, 1991), 44.

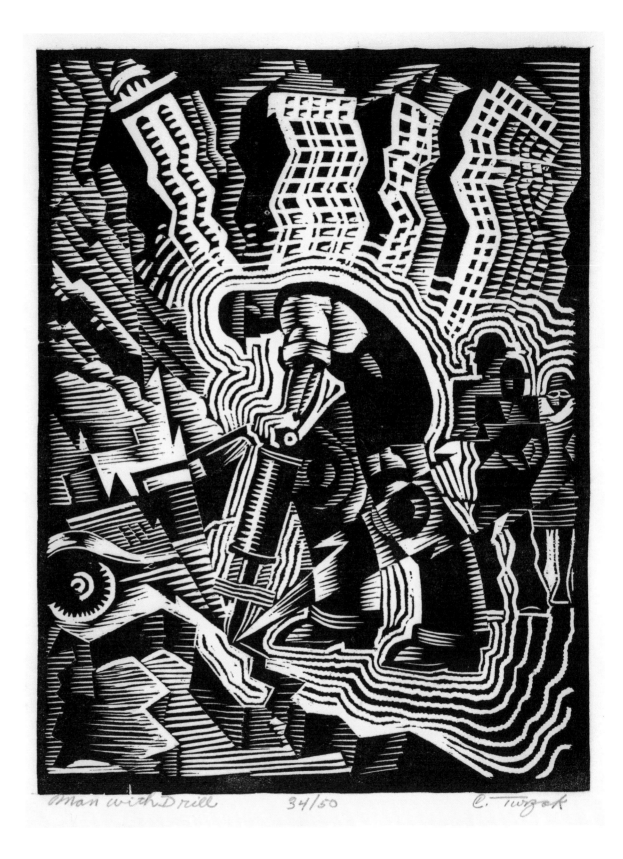

Man with Drill 34/50 C. Turzak

20. Charles Turzak Man with Drill, ca. 1935 woodcut

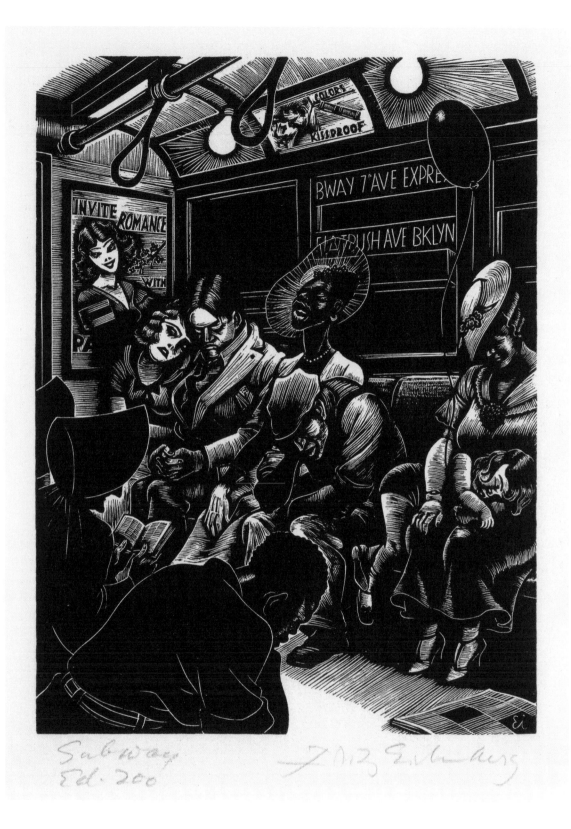

Subway
Ed. 200

Fritz Eichenberg

21. Fritz Eichenberg Subway, 1934 wood engraving

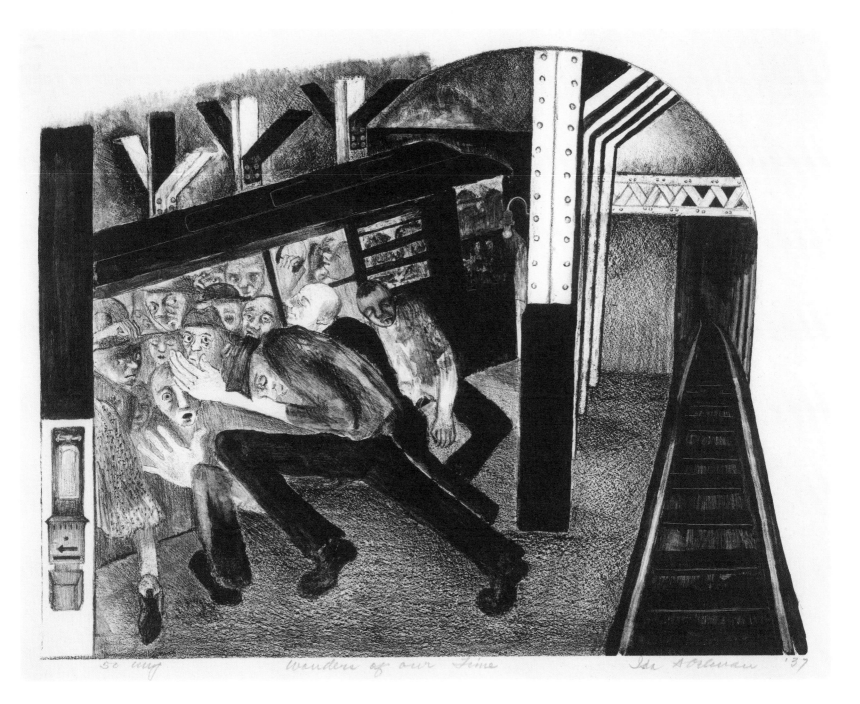

50 *mip* Wonders of our Time Ida Abelman '37

22. Ida Abelman Wonders of Our Time, 1937 lithograph

2nd State number 9 Snow Shovelers, New York Clare Leighton

23. Clare Leighton Snow Shovelers, New York, 1929 wood engraving

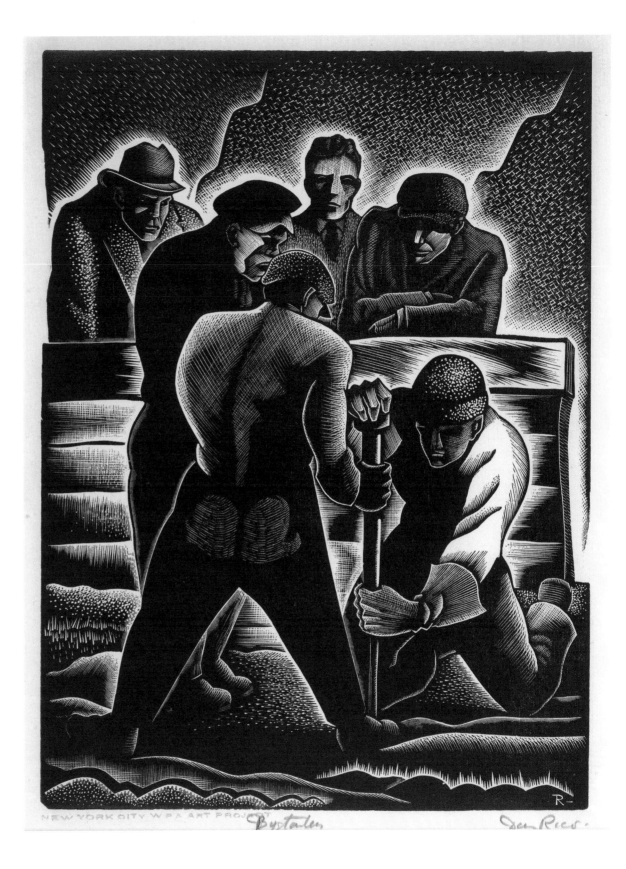

24. Donato (Dan) Rico Bystander, ca. 1936–42 wood engraving

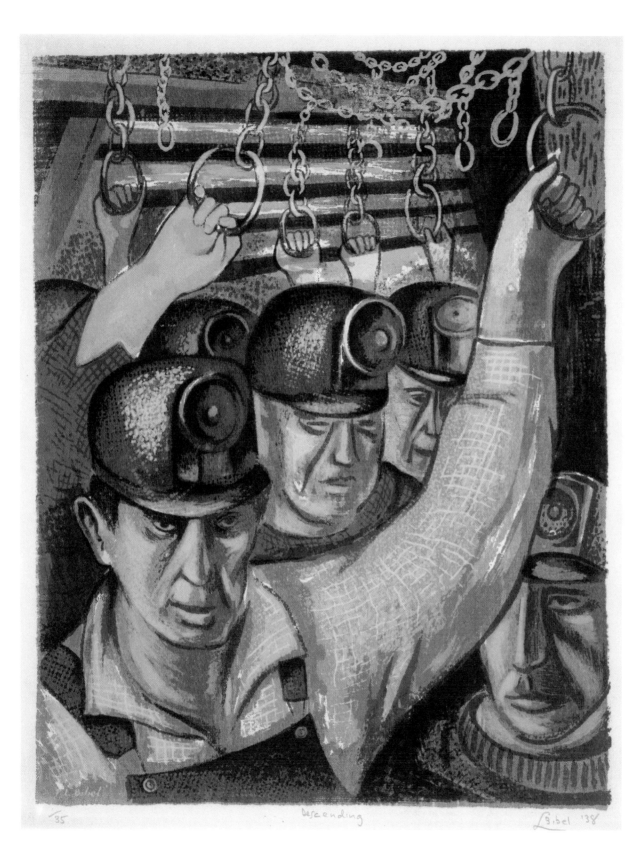

25. Leon Bibel Descending, 1938 color screenprint

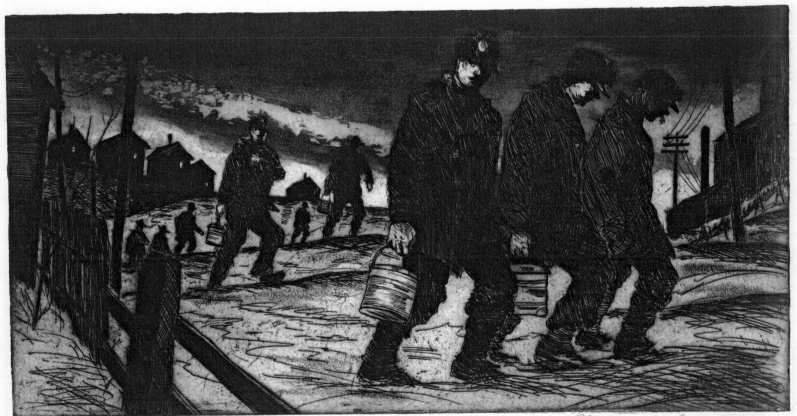

"Scranton Coal Miners" Michael J Gallagher.

26. Michael J. Gallagher Scranton Coal Miners, ca. 1938 etching and carborundum print

GETTING BY IN HARD TIMES

Artists depicted the devastating toll the economic depression of the 1930s, known as the Great Depression, took on America, perhaps because they were among those most affected by it. The prints in this section focus on how people fulfilled the most basic human need—eating—with little or no money. Paul Cadmus, Reginald Marsh, and Raphael Soyer were part of a second generation of artists influenced by Robert Henri, John Sloan, and George Bellows, and shared their keen observation of urban life.

Paul Cadmus is known for his satirical paintings and prints. The etching *Stewart's* (pl. 27) was based on his painting titled *Greenwich Village Cafeteria* (1934; United States Public Works of Art Project). According to Cadmus, Stewart's restaurant "was cheap. I seem to remember that with a main course—usually less than 50 cents—soup, rolls, and coleslaw were thrown in. The place was so very popular—it was full of beatniks, delinquents, minor gangsters of its day. . . . Enjoying an even cheaper form of entertainment were the people outside the plate glass windows—three and four deep at times— watching the freaks inside."[1] Cadmus, however, placed the viewer inside Stewart's, among the "freaks," by truncating and foreshortening the woman and chair at the far left, suggesting that our space is contiguous with hers.

Handouts were the only option for those unable to afford even a fifty-cent meal. Raphael Soyer and Reginald Marsh created their prints early in the Depression, when churches and private charities, rather than the government, tried to provide relief for impoverished Americans. Soyer's lithograph *The Mission* (pl. 28) is a touching character study of down-and-out men dining on a meager repast of free sandwiches and coffee. Carl Zigrosser, long-time Curator of Prints and Drawings at the Philadelphia Museum of Art, characterized Soyer in 1942 as "a voice of the nameless multitude, the downtrodden and underprivileged, the immigrant aspiring to freedom and a full life, and floundering in, oh, what a mockery of it."[2] Soyer's own experience as a poor immigrant growing up in a tenement allowed him to sympathize with his subjects.

Reginald Marsh expressed the scope of the Depression in *Breadline—No One Has Starved* (pl. 29) by creating a line of unemployed men without beginning or end, locking them into a shallow space, and tightly cropping the image at top and bottom, all to suggest that their possibilities in life are extremely limited. Marsh's title referred to a widely held belief in 1932 that the Hoover administration had not taken the Depression seriously because "no one had starved," but instead reckoned that a little belt-tightening would improve Americans' "fiber." This lack of response to the escalating national crisis prompted author, playwright, and literary critic Edmund Wilson to respond: "It is a reassuring thought that the emaciated men in the breadlines, the men and women beggars in the streets, and the children dependent on them are all having their fiber hardened."[3]

Note 1 Paul Cadmus, quoted in Lincoln Kirstein, *Paul Cadmus* (New York: Imago, 1984), 26.

Note 2 Carl Zigrosser, *The Artist in America: Twenty-four Close-ups of Contemporary Printmakers* (New York: Knopf, 1942), 58.

Note 3 Edmund Wilson, *The American Jitters: A Year of the Slump* (New York: Charles Scribner's Sons, 1932), 3.

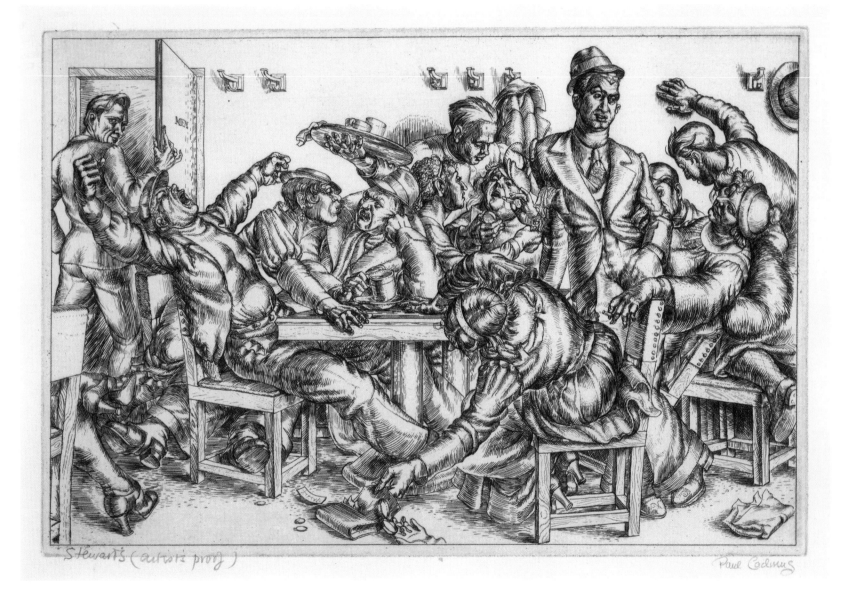

27. Paul Cadmus Stewart's, 1934 etching

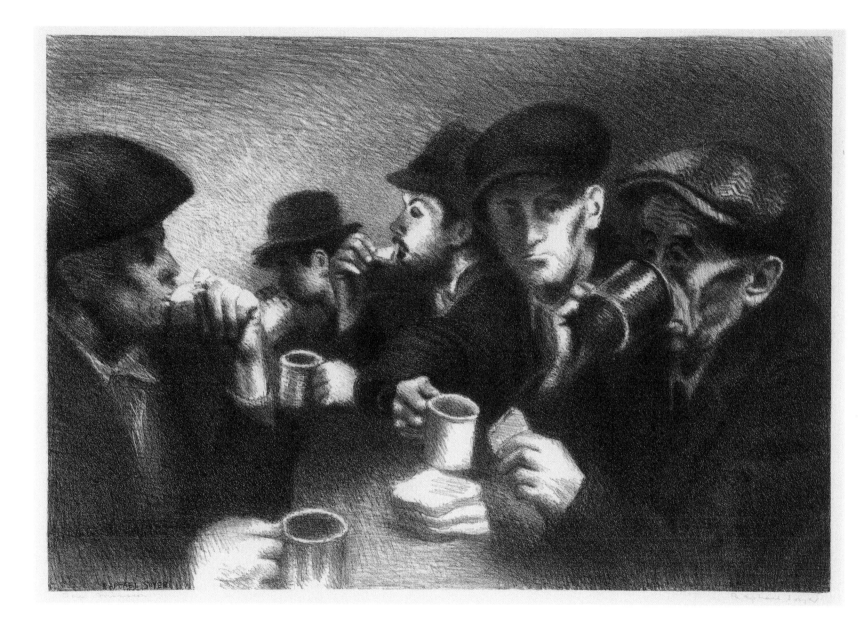

28. Raphael Soyer The Mission, 1933 lithograph

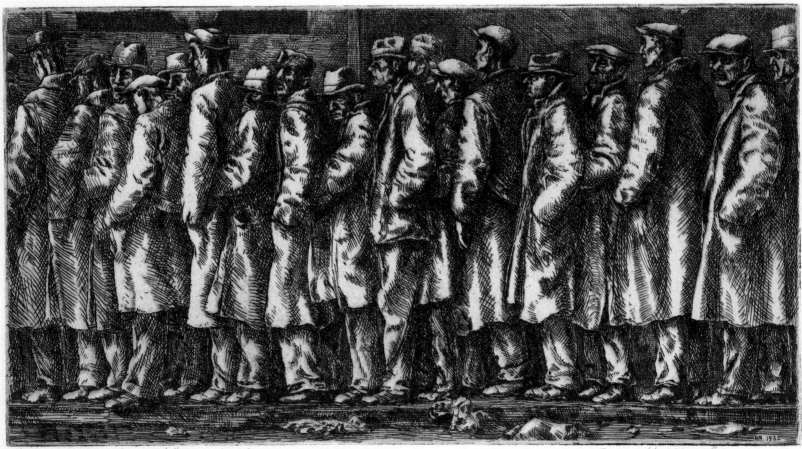

"No One has Starved"— 1932 —Reginald Marsh

29. Reginald Marsh Bread Line—No One Has Starved, 1932 etching and engraving

INTIMATE MOMENTS AND SMALL TOWN LIFE

American artists often left the city temporarily to find inspiration in nature and escape summer heat. They gathered in the Hamptons and Woodstock, New York; Cos Cob, Connecticut; and Gloucester, Massachusetts. Although removed from the city they explored the same subjects: architecture, society, and atmosphere. The slower pace of life in the country is reflected in artists' images of people. Peggy Bacon, Childe Hassam, and other printmakers captured their subjects in private, intimate moments that stand in marked contrast to the frenetic scenes of urban life presented in previous sections.

Bacon and Hassam worked primarily in etching and drypoint. *Casual Ablutions* (pl. 30) depicts Bacon's husband, the painter Alexander Brook. Bacon studied with John Sloan and George Bellows at the Art Students League in New York and, like them, she portrayed life based on her experience. Her prints are often humorous, as in her labeling Brook's washing and shaving in their cramped apartment as "ablutions," a word associated with cleansing for religious rituals.

Childe Hassam's prints relate to the tradition of late nineteenth-century etchings by American expatriate James Abbott McNeill Whistler and his followers in England and the United States, who created exquisitely crafted prints in small editions. *The Lion Gardiner House, East Hampton* (pl. 32) demonstrates Hassam's impressionistic style, as he captured the ephemeral effects of a complex web of light and shadow playing across the house. *The White Kimono* (pl. 31), created in Cos Cob, exhibits the Impressionists' interest in Japanese aesthetics, which they learned about primarily from imported woodblock prints. The simplicity of the composition, shallow perspective, and the kimono derive from Japanese printmaking as well as from the aesthetic interests of Whistler and his followers.

Wet Night, Route 6 (pl. 34) depicts the highway near Martin Lewis's home in Sandy Hook, Connecticut, where he moved when the Depression forced him to sell his studio and home in New York.[1] As compared to Bacon's drypoint technique, which essentially created a line drawing, Lewis scratched small lines closely together throughout the plate to produce subtle differences in tone. In *Down to the Sea at Night* (pl. 35) he applied sandpaper to an etching plate prepared with ground and passed them through the press. The grains of sand created tiny pits in the ground that, when etched with acid, left a texture on the plate. The texture created by the sand held the ink during printing to produce the overall effect of night.

Benton Spruance's *Road from the Shore* (pl. 36) is the antipode of Lewis's *Wet Night, Route 6*. For Lewis the car was interesting for the chiaroscuro effects created by headlights shining into darkness. Spruance, in this and other lithographs, depicted the danger caused by speed and reckless driving. Ominous black cars race toward each other with abandon, and terrible accidents seem unavoidable. Death waits to claim the victims.

Note 1 Paul McCarron, *The Prints of Martin Lewis: A Catalogue Raisonné* (Bronxville, NY: M. Hausberg, 1995), 8.

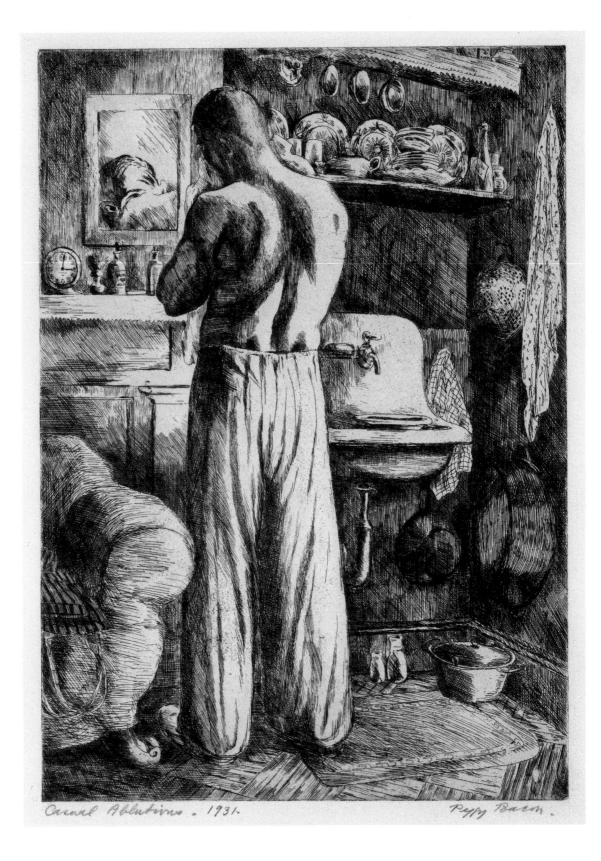

Casual Ablutions . 1931 . Peggy Bacon .

30. Peggy Bacon Casual Ablutions, 1931 etching

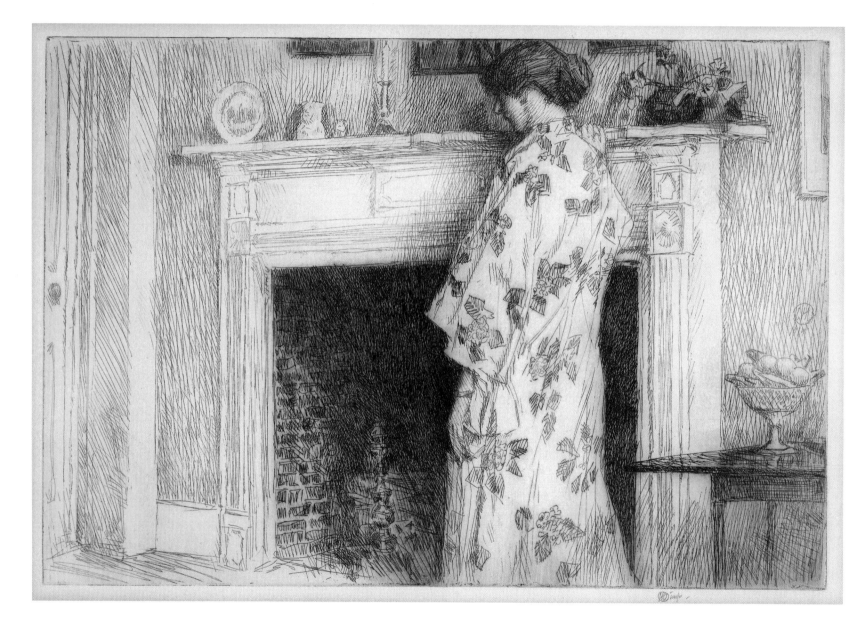

31. Childe Hassam The White Kimono, 1915 etching

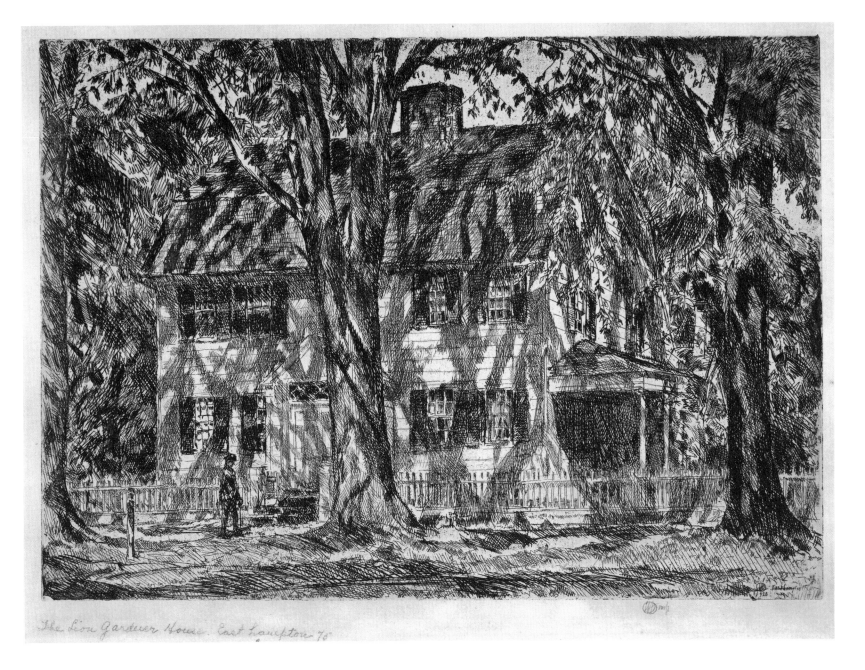

The Lion Gardiner House. East Hampton 75

32. Childe Hassam The Lion Gardiner House, East Hampton, 1920 etching

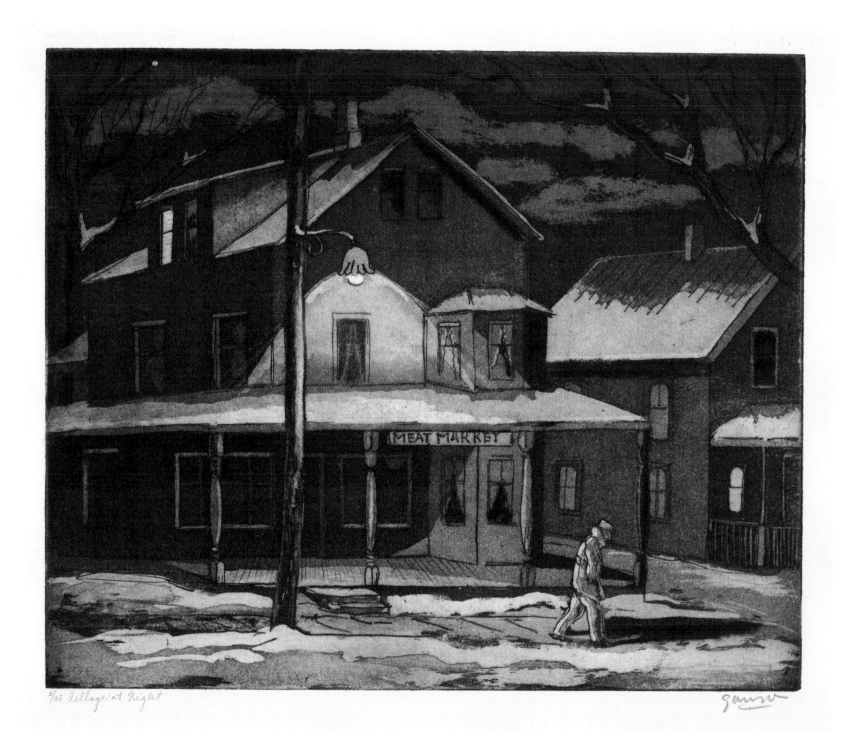

3/35 Village at Night Ganso

33. Emil Ganso Village at Night, n.d. etching and aquatint

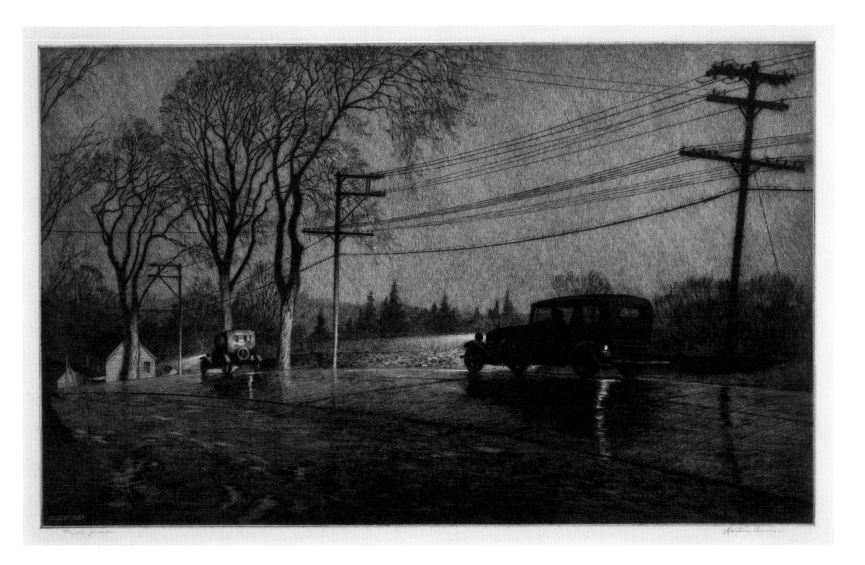

34. Martin Lewis Wet Night, Route 6, 1933 drypoint

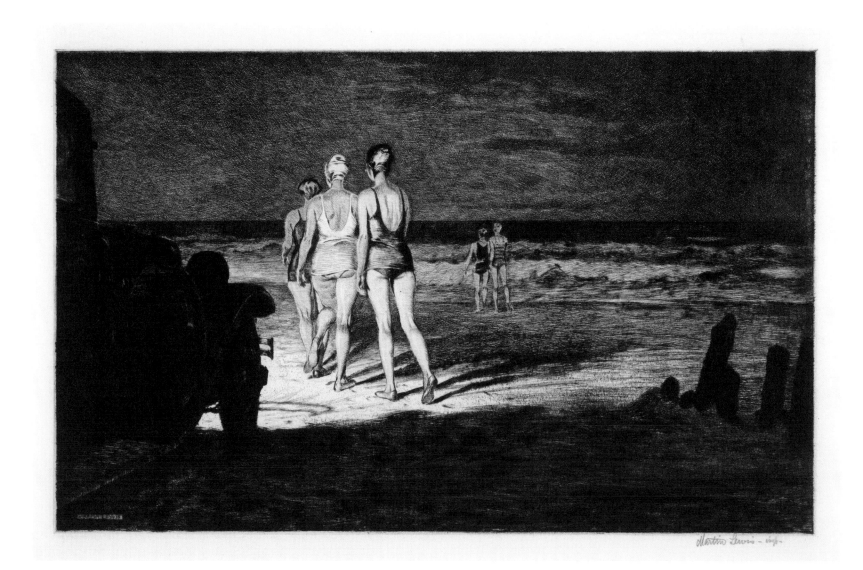

35. Martin Lewis Down to the Sea at Night, 1929 drypoint and sand-ground etching

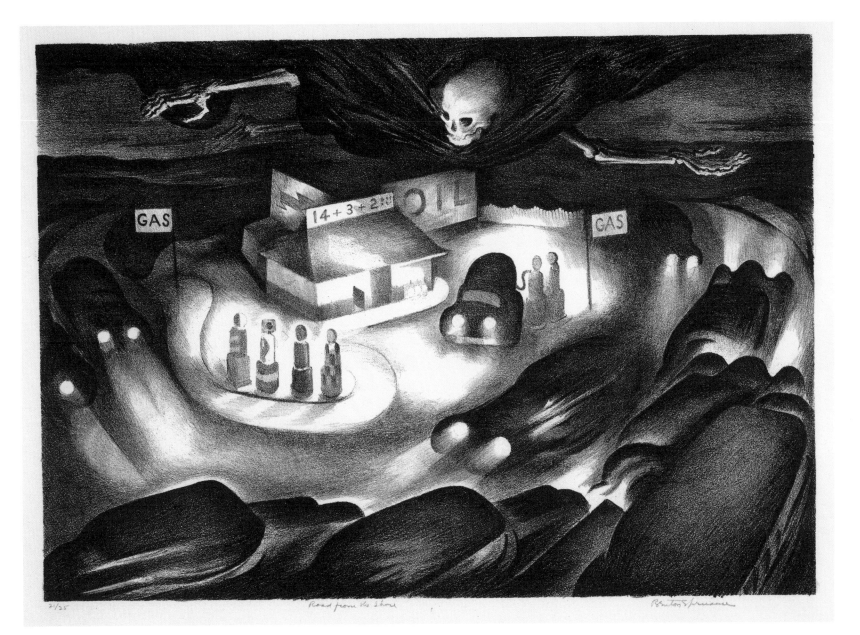

GAS

14 + 3 + 2?!!

OIL

GAS

2/25 Road from the Shore Benton Spruance

36. Benton Spruance Road from the Shore, 1936 lithograph

FARMS AND FARMING

Note 1 United States Department of Commerce, Bureau of the Census, *Historical Statistics of the United States, Colonial Times to 1970*, "Estimated Annual Movement of the Farm Population: 1920–1970," Series C 76–80, (Washington, D.C.: U.S. Government Printing Office, 1975), 96.

Note 2 Thomas Craven, ed. *A Treasury of American Prints, A Selection of One Hundred Etchings and Lithographs by the Foremost Living American Artists* (New York: Simon and Schuster, 1939), plate 94, verso.

Note 3 Thomas Hart Benton, quoted in Creekmore Fath, *The Lithographs of Thomas Hart Benton* (Austin, TX, and London: University of Texas Press, 1979), 74.

Note 4 Louis Lozowick, "The Americanization of Art," 1927 in *The Prints of Louis Lozowick, A Catalogue Raisonné*, ed. Janet Flint (New York: Hudson Hills Press, 1982), 18.

Note 5 Robert Gwathmey, interviewed by Elizabeth MacCausland, *Magazine of Art* 39, no. 4 (April 1946): 149.

Although most of America's population lived in cities by 1920, the Jeffersonian ideal of the United States as a nation of farmers who worked their own land persisted. A group of artists called Regionalists, most prominently including Grant Wood, Thomas Hart Benton, and John Steuart Curry, believed that authentic American culture and values were found in farm communities, particularly those of the Midwest, rather than in cities. Regionalists worked in a realistic style, which they considered to be more American than modern movements with European origins like Cubism and Futurism.

Against the background of the massive displacement of farmers due to the Dust Bowl and mechanization, Regionalists idealized the experience of farming. From 1920 to 1950, the number of American farmers decreased by almost nine million.[1] Thomas Craven, a critic who championed Regionalism, called Wood's *July Fifteenth* (pl. 37) "the portrait of America's most valuable wealth. No dust bowl here, no starved cattle or skulls bleaching on cracked surfaces."[2] Benton's lithograph *Cradling Wheat* (pl. 40) celebrates the communal aspects of American farming, although the artist admitted, "I don't know whether this kind of farming can be found anymore—anywhere."[3] Bernard Steffen studied with Benton at the Kansas City Art Institute. The curvilinear composition of his color screenprint *Haying* (pl. 41) demonstrates Benton's influence, and shares with *Cradling Wheat* an emphasis on the heroic physicality of farm labor. In this group of prints, only Doris Lee's *Helicopter* (pl. 42) depicts the introduction of machines into farm life, although the humor of her lithograph mitigates any anxiety.

Agricultural America did attract modernist artists. Benton Spruance imposed geometry and a Cubist grid to *American Pattern—Barn* (pl. 39). Louis Lozowick used a Precisionist style to depict industrial agricultural production. His *Granaries of Democracy* (pl. 38) depicts monumental grain silos in Omaha, Nebraska. The endless lines of trains transporting grain to and from them express his belief that: "The history of America is a history of stubborn and ceaseless effort to harness the forces of nature— a constant perfecting of the tools and process with which to make mastery of these forces possible. The history of America is a history of gigantic engineering feats and colossal mechanical constructions."[4] Robert Gwathmey's *Topping Tobacco* (pl. 43) shows the influence of Pablo Picasso's Synthetic Cubism, with its flattened forms and bright, localized colors. Gwathmey concentrated on social issues in his native South, particularly race. Having returned there after studying art in the Northeast, he was "shocked by the poverty. The most shocking thing was the Negroes, the oppressed segment. . . . When people ask me why I paint the Negro, I ask 'Don't artists have eyes?'"[5]

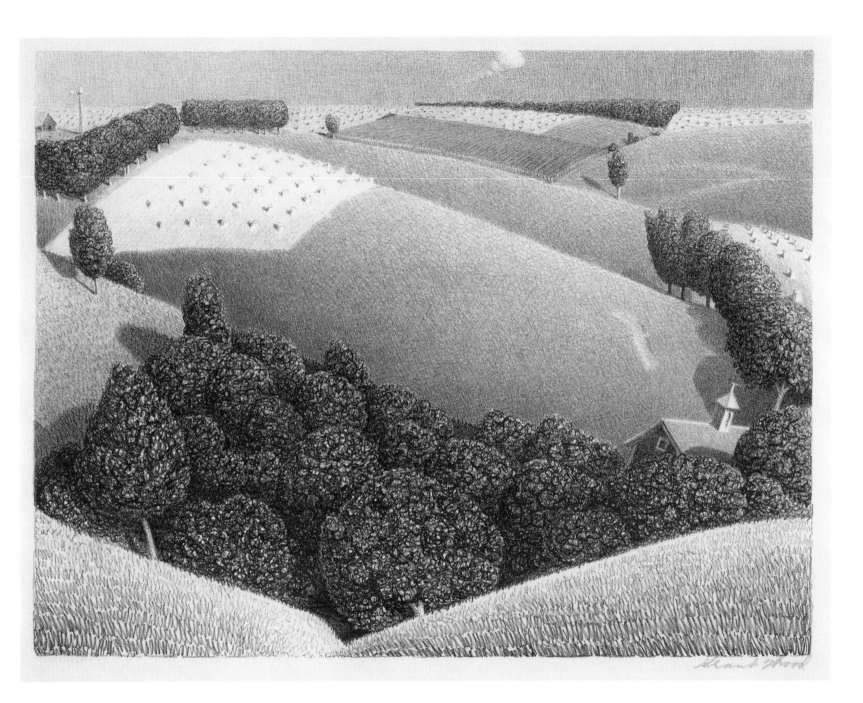

37. Grant Wood *July Fifteenth, 1939* lithograph

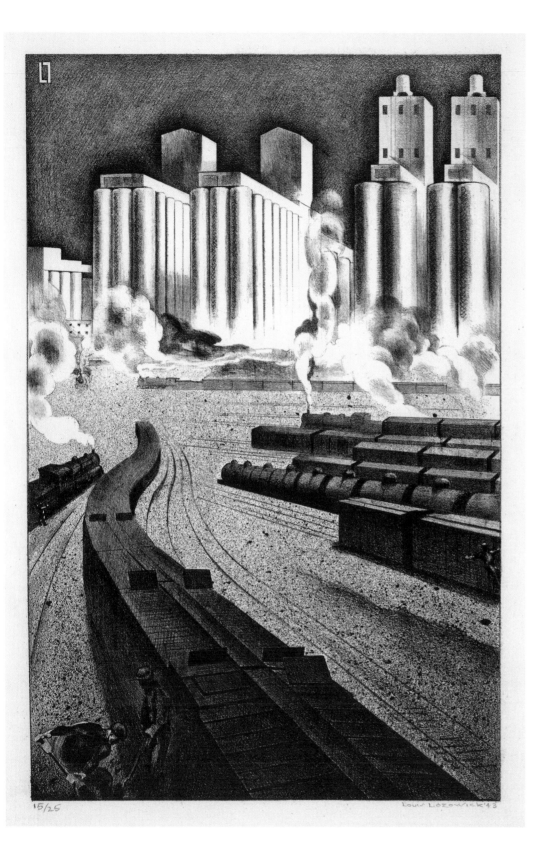

15/25 Louis Lozowick '43

38. Louis Lozowick Granaries of Democracy, 1943 lithograph

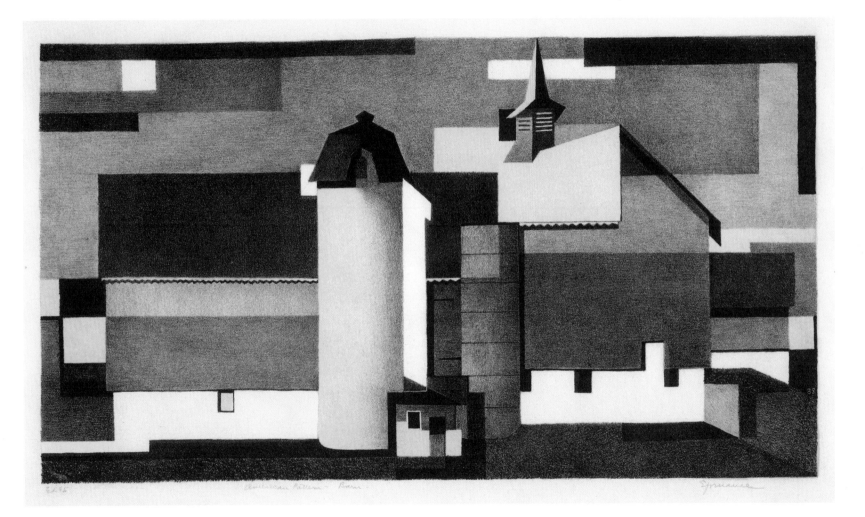

39. Benton Spruance American Pattern—Barn, 1940 lithograph

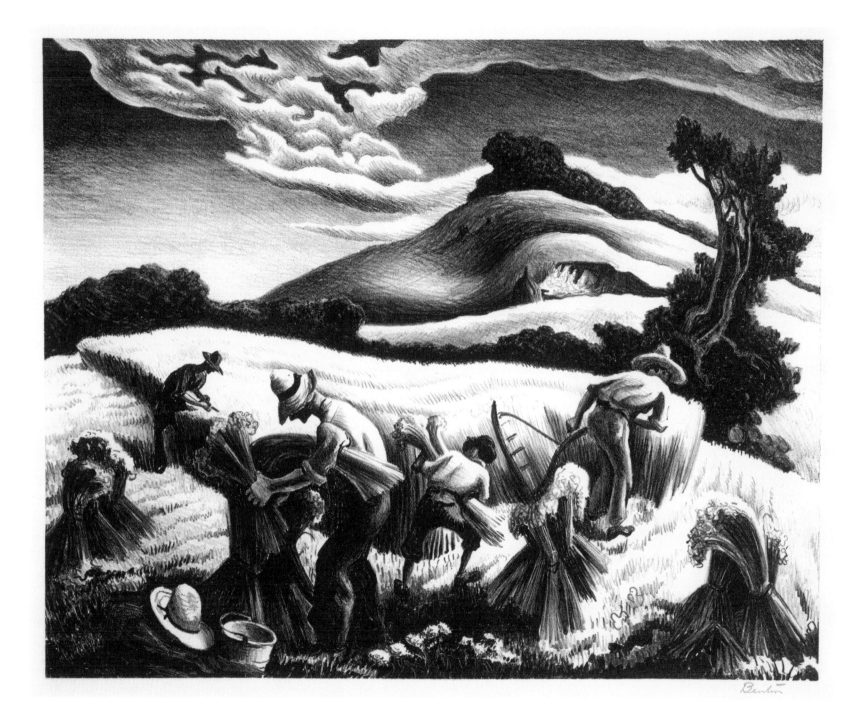

40. Thomas Hart Benton Cradling Wheat, 1939 lithograph

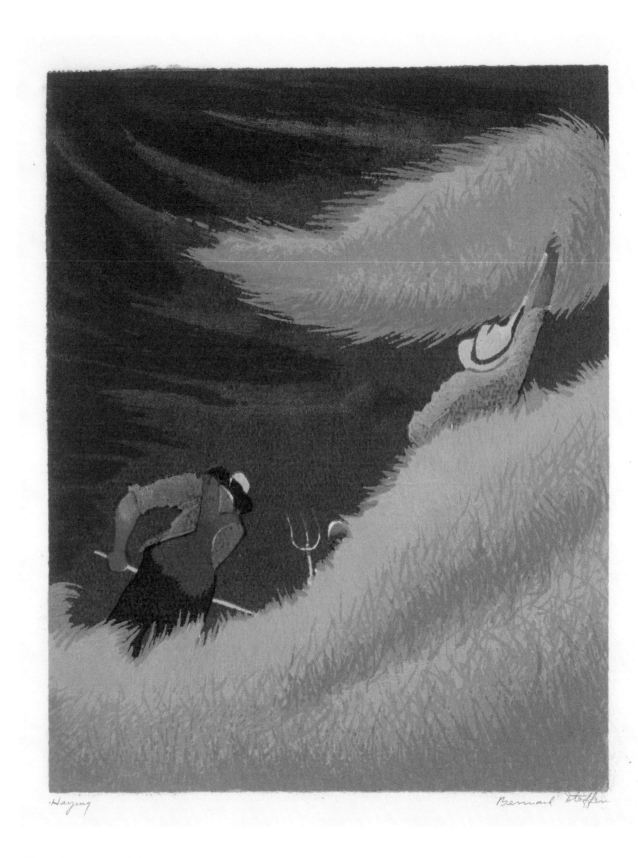

Haying Bernard Steffen

41. Bernard Steffen Haying, 1946 color screenprint

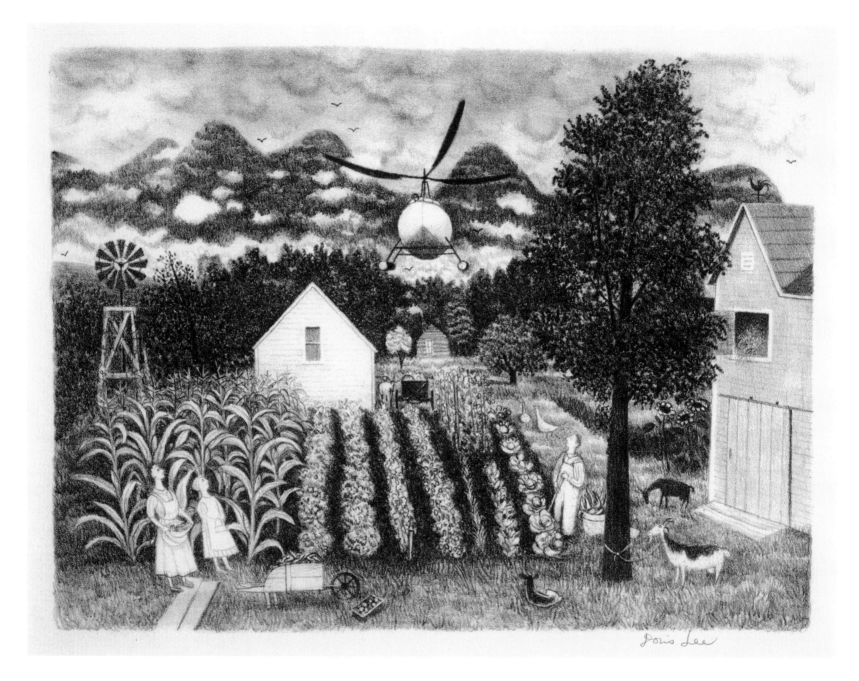

42. Doris Lee Helicopter, 1948 lithograph

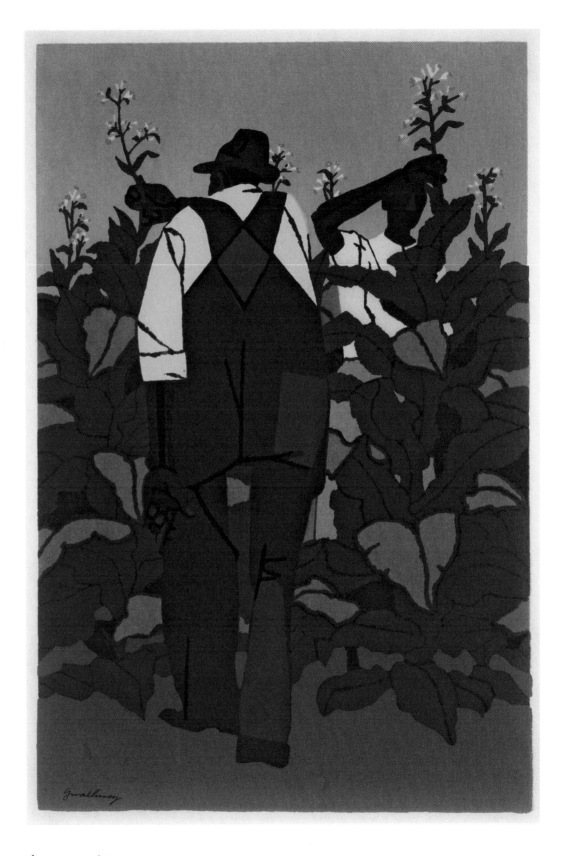

43. Robert Gwathmey Topping Tobacco, 1947 color screenprint

DESPERATION AND FLIGHT

DESPERATION AND FLIGHT

Note 1 Helen Langa, *Radical Art, Printmaking and the Left in 1930s New York* (Berkeley and Los Angeles: University of California Press, 2004), 153.

Note 2 Thomas Hart Benton, quoted in Creekmore Fath, *The Lithographs of Thomas Hart Benton* (Austin, TX, and London: University of Texas Press, 1979), 88.

Note 3 Frederick Lewis Allen, *Since Yesterday: The Nineteen Thirties in America* (New York: Harper Brothers, 1940), 60.

Note 4 Robert Gwathmey, interviewed by Elizabeth MacCausland, *Magazine of Art* 39, no. 4 (April 1946): 151.

Many American artists addressed social issues during the Depression by commenting directly on the crisis, as in Reginald Marsh's *Breadline—No One Has Starved* (pl. 29), or focusing on misfortunes of the worker, as Michael Gallagher did in *Scranton Coal Miners* (pl. 26). John Steuart Curry illustrated the Depression's effect on race relations, as hard times aggravated old prejudices, when he sent *The Fugitive* (pl. 44) to the exhibition "An Art Commentary on Lynching," sponsored by the National Association for the Advancement of Colored People in 1935.[1] The powerful image of an African American in a Christ-like pose fleeing the mob intent on killing him is made more dramatic because the outcome is unclear. Curry designed the image to arouse our sympathy, direct our attention to the problem of racial violence, and affect social change.

Thomas Hart Benton's lithograph *Departure of the Joads* (pl. 45) shows another form of desperate flight during the Depression. In John Steinbeck's 1939 novel, *The Grapes of Wrath*, the Joad family left Oklahoma after the foreclosure of their farm, joining hundreds of thousands of migrants from the Dust Bowl chasing opportunity in California. Twentieth Century Fox commissioned Benton to make six lithographs illustrating the novel, which were enlarged as billboard-size advertisements for the 1940 film adaptation of Steinbeck's book.[2] Benton's Regionalist style, which featured American folk, had become widely popular in the 1930s, landing him on the cover of *Time* magazine in 1934.

Robert Gwathmey's color screenprint *The Hitchhiker* (pl. 46) depicts "the vastly increased thumbers on the highway . . . a huge army of drifters ever on the move, searching half-aimlessly for a place where they might find a job."[3] His ironic juxtaposition of the downtrodden hitchhikers with bright billboards promising a life in America that eludes them resembles photographs taken for the Farm Security Administration by Dorothea Lange. *The Hitchhiker*, like many of Gwathmey's works, includes few figures because he believed that "limited imagery is the best method of presentation of your content."[4]

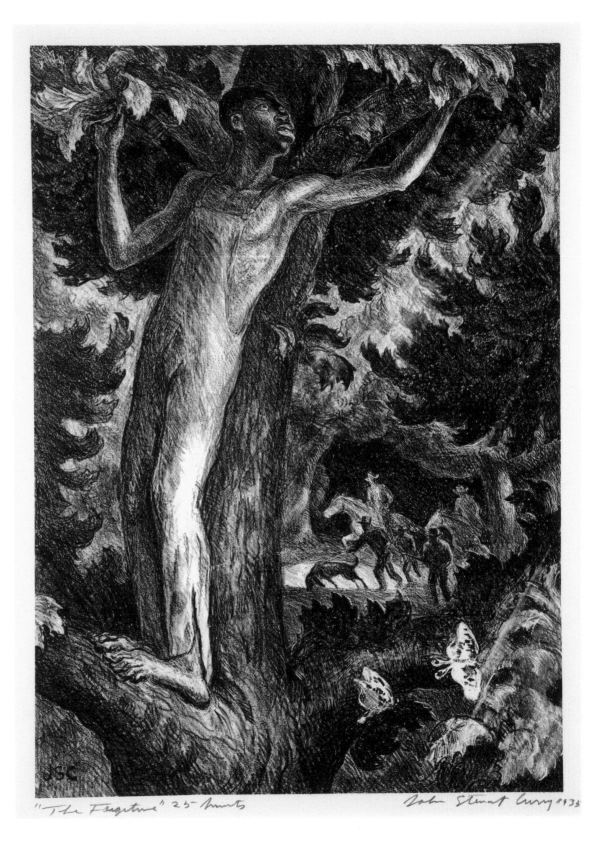

"The Fugitive" 25 prints John Steuart Curry 1935

44. John Steuart Curry The Fugitive, 1935 lithograph

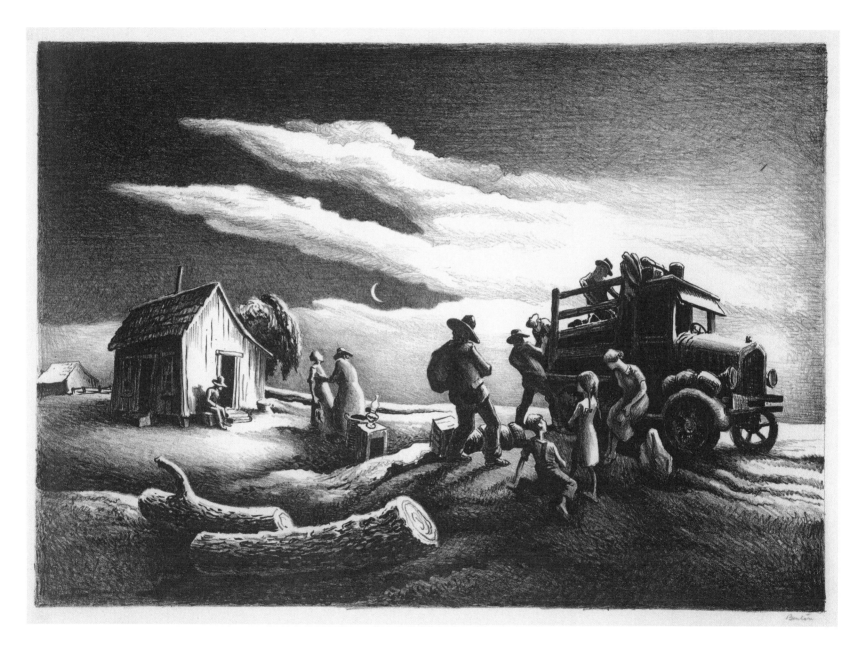

45. Thomas Hart Benton Departure of the Joads, 1939 lithograph

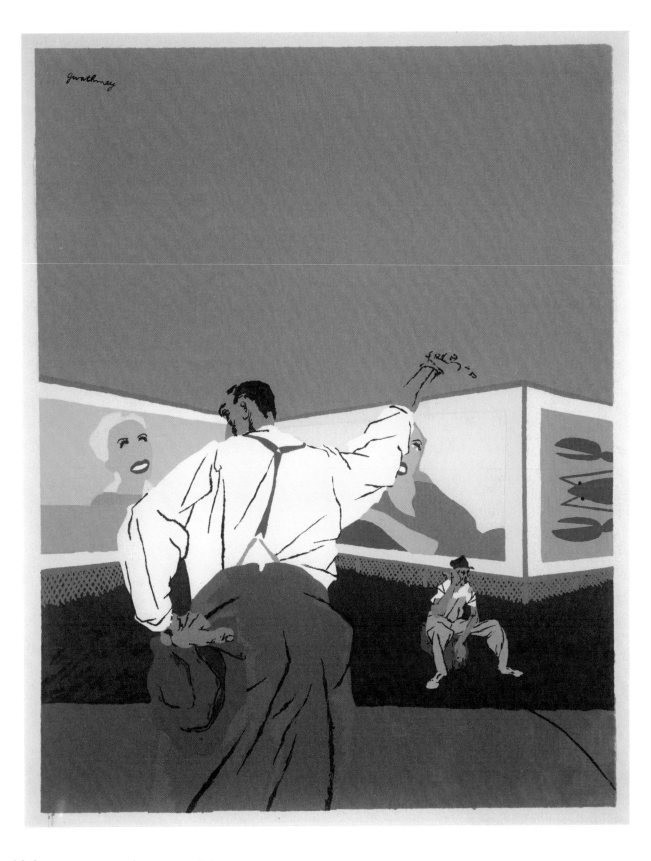

46. Robert Gwathmey The Hitchhiker, ca. 1937 color screenprint

THE CALIFORNIA LANDSCAPE

California represented hope during the Depression for the fictional Joad family and nearly a million people who settled in the state between 1930 and 1940, while the Great Plains as well as Oklahoma, Texas, and Arkansas hemorrhaged population.[1] Gustave Baumann, Paul Landacre, and Franz Geritz came to California from other states and countries, which likely affected their images of the West.

Singing Woods (pl. 47) would have been praised by the boosters who promoted migration to California, as Gustave Baumann presented an idyllic slice of landscape in lush colors. Baumann, a German immigrant who studied at the Art Institute of Chicago, was a master of the color woodcut, a demanding technique in which each color requires its own block that must register exactly with the others to avoid blurring the image. *Singing Woods* required six separate blocks. Baumann also formulated his own inks to produce the depth of color he preferred, and in this image used aluminum leaf to convey the clear, bright California light.

Franz Geritz, a Hungarian immigrant, was active in Los Angeles by 1922. He used the relatively simple method of linocut to create *Craters, Mono Lake* (pl. 48). The broad areas of bright white paper and unmodulated black ink convey the bleak expanse of desert in eastern California.

Writers on American prints, including curator Carl Zigrosser and printmaker Rockwell Kent, considered Paul Landacre to be one of the best wood engravers in the United States. Landacre settled in Los Angeles in 1916, studied at The Otis School of Art and Design, and worked as a commercial illustrator. After experimenting with a variety of print media, he started wood engraving in 1927. The medium appealed to him for its ability to produce crisp distinctions between white and black with precise lines. Unlike most American printmakers, he printed his own work on a nineteenth-century press, allowing him to control the creative process from inception to finished work. In *Death of a Forest* (pl. 49), Landacre's elaborate system of hatching and crosshatching expresses the heat and smoke of a fire in the mountains surrounding Los Angeles, an all-too-common occurrence in late summer and early fall.

Note 1 United States Department of Commerce, Bureau of the Census, *Historical Statistics of the United States, Colonial Times to 1970*, "Estimated Net Intercensal Migration of Total, Native White, Foreign-Born White, and Negro Populations by State: 1870–1970," Series C 25–75 (Washington, D.C.: U.S. Government Printing Office, 1975), 95.

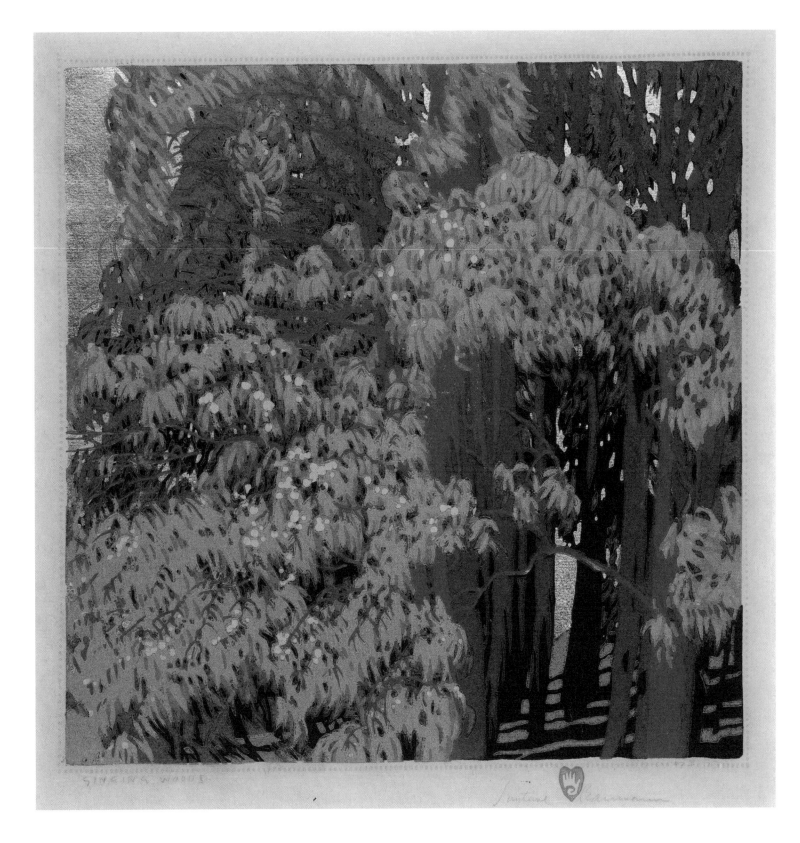

47. Gustave Baumann Singing Woods, 1928 color woodcut with aluminum leaf

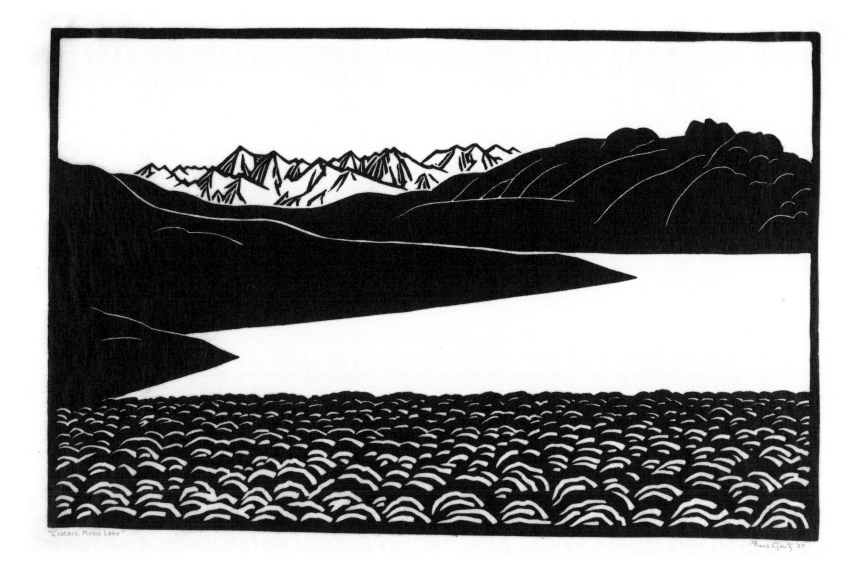

"Craters, Mono Lake"

Franz Geritz '27

48. Franz Geritz Craters, Mono Lake, 1927 linocut

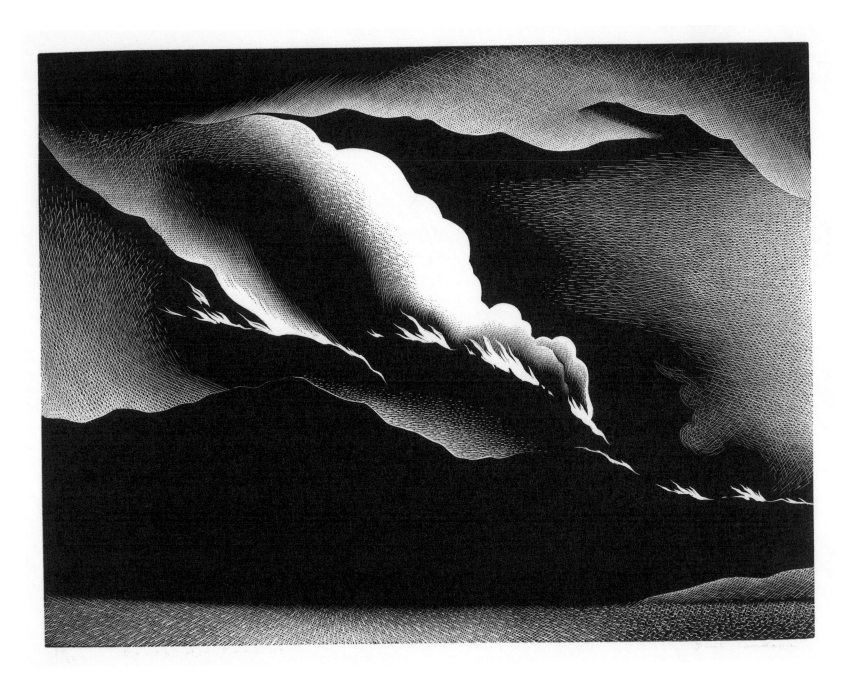

49. Paul Landacre Death of a Forest, 1938 wood engraving

WORLD WAR II

When the United States entered World War II in 1941, American printmakers rallied to the cause. In January of 1942 artists established the organization Artists for Victory, Inc. which swelled to ten thousand members. Following in the tradition of Goya's *Disasters of War* etchings and Pablo Picasso's painting *Guernica*, members of Artists for Victory depicted the effects of the war on the battlefield and the home front, producing uplifting images of soldiers and factory workers, as well as emphasizing the enemy's cruelty.

In 1943, Artists for Victory, taking advantage of the multiple nature of the print, held exhibitions of the same one hundred prints in twenty-six museums across the United States.[1] Both *Assembly Line* (pl. 50) by Jolán Gross-Bettelheim and *Patterns for Victory* (pl. 52) by Riva Helfond were included in the "America in the War" exhibition. Gross-Bettelheim was well-versed in European modernism, having grown up in Hungary before coming to the United States in 1925 and traveling to the Soviet Union in 1933. *Home Front* is influenced by the mechanistic Cubism of Fernand Léger with its repetitive forms of identical women who are subsumed under endless rows of bombs and industrial equipment. In the context of the "America in the War" exhibition, the print illustrated the contributions women made to the war effort, as well as the efficiency of weapons production. Riva Helfond's color screenprint depicts an aspect of the war itself, and the repetitive pattern of paratroopers suggests that the amount of manpower America mobilized for the war assured victory. Her imagery is reminiscent of propaganda posters created by the government for the war.

Rumors of War, Washington, D.C. (pl. 51) by Pele deLappe depicts the anxiety Americans felt as war seemed inevitable after Germany's invasion of Poland. Her approach to the figure was academic, concentrating on accurate depiction of the human body in a variety of poses, but deLappe was also friends with Mexican artists Frida Kahlo, Diego Rivera, and David Alfaro Siqueiros, and their interest in Surrealism influenced her work.[2] Although realistically rendered, the figures in *Rumors of War, Washington, D.C.* inhabit an ambiguous space and have no clear relation to one another, lending the work a disconcerting air common to the work of Surrealists.

Note 1 For a complete list of the artists included in the "America in the War" exhibition and history of Artists for Victory, see Ellen Landau, *Artists for Victory* (Washington, D.C.: Library of Congress, 1983).

Note 2 Elizabeth G. Seaton, ed., *Paths to the Press: Printmaking and American Women Artists, 1910–1960* (Manhattan, Kansas: Beach Museum of Art, University of Kansas, 2006), 120.

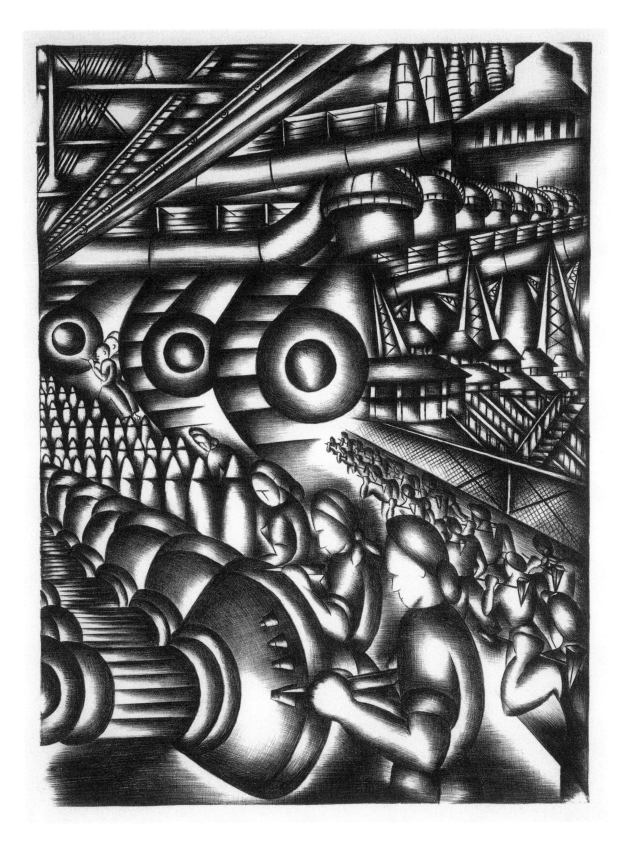

50. Jolán Gross-Bettelheim Assembly Line, 1942 lithograph

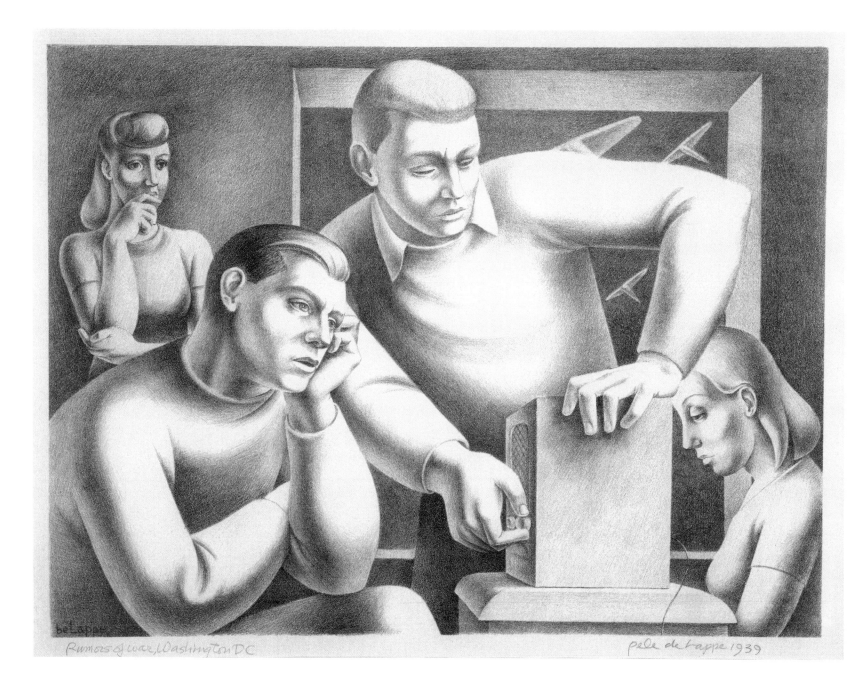

51. Pele (Phyllis) deLappe Rumors of War, Washington, D.C., 1939 lithograph

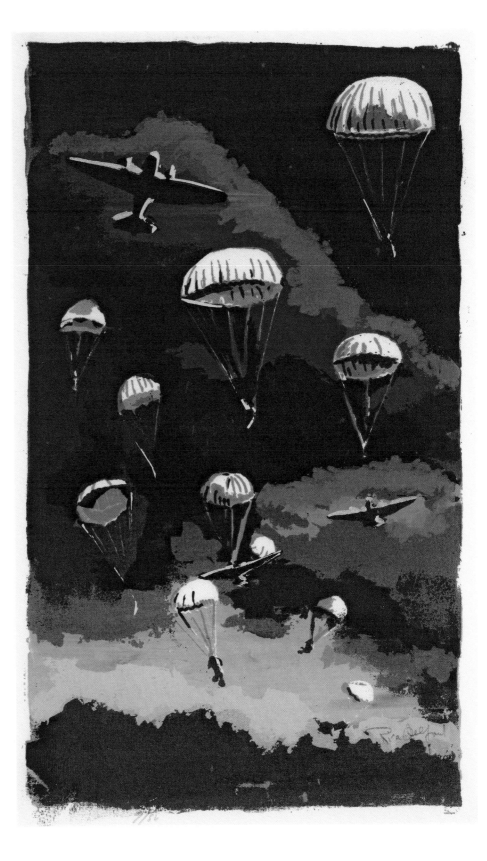

52. Riva Helfond Patterns for Victory, 1943 color screenprint

PRINTS AS ILLUSTRATIONS AND ADVERTISING

Printmakers in the first half of the twentieth century had many opportunities to disseminate their work to the public. In addition to art galleries, such as the Weyhe Gallery in New York, the Associated American Artists company commissioned prints and sold them through a mail-order catalog beginning in 1934. As discussed earlier, *The Masses* and *The New Republic* sold prints for a nominal fee with subscriptions.

Illustrating books and advertisements were another source of income and exposure for printmakers. John Sloan created a number of his earliest etchings as illustrations for general-interest books including *Homes of the Poets* and the novels of French author Charles Paul de Kock. As previously noted, Twentieth Century Fox used Thomas Hart Benton's *Departure of the Joads* (pl. 45) to market their film of *The Grapes of Wrath*.

Rockwell Kent created *Homeport* (pl. 53) as one of twelve wood engravings used to advertise the American Car and Foundry Company, which manufactured train and subway cars, buses, and automotive parts. They published his engravings in several magazines, including *Time*, *Town and Country*, and *The American Mercury* between July of 1930 and August of 1931; *Homeport* appeared in December 1930 and July 1931. Rather than advertising a specific product, reproductions of the wood engravings were displayed without text other than Kent's name, the title of the work, and its medium. American Car and Foundry's name appeared below the illustration, at the bottom of the page.[1]

Kent and other artists, including Thomas Hart Benton, approached advertising cautiously. Although commissions increased exposure to artists' work and paid well, advertising agencies and corporations sometimes made demands that they felt conflicted with their artistic integrity. The American Car and Foundry Company commission represented for Kent the ideal marriage between art and commerce because the corporation allowed him freedom of expression without scrutiny. Kent believed that if corporations sponsored artists, rather than dictating style and subject to the artist, "advertising through its facilities for mass distribution, can be a great factor in the promotion of a people's culture."[2]

Note 1 Dan Burne Jones, *The Prints of Rockwell Kent: A Catalogue Raisonné*, revised by Robert Rightmire (San Francisco: Alan Wofsy Fine Arts, 2002), xxx and 122.

Note 2 Rockwell Kent, "Dictators of Art," in *Work for Artists: What? Where? How?*, ed. Elizabeth MacCausland (New York: American Artists Group, 1947), 68.

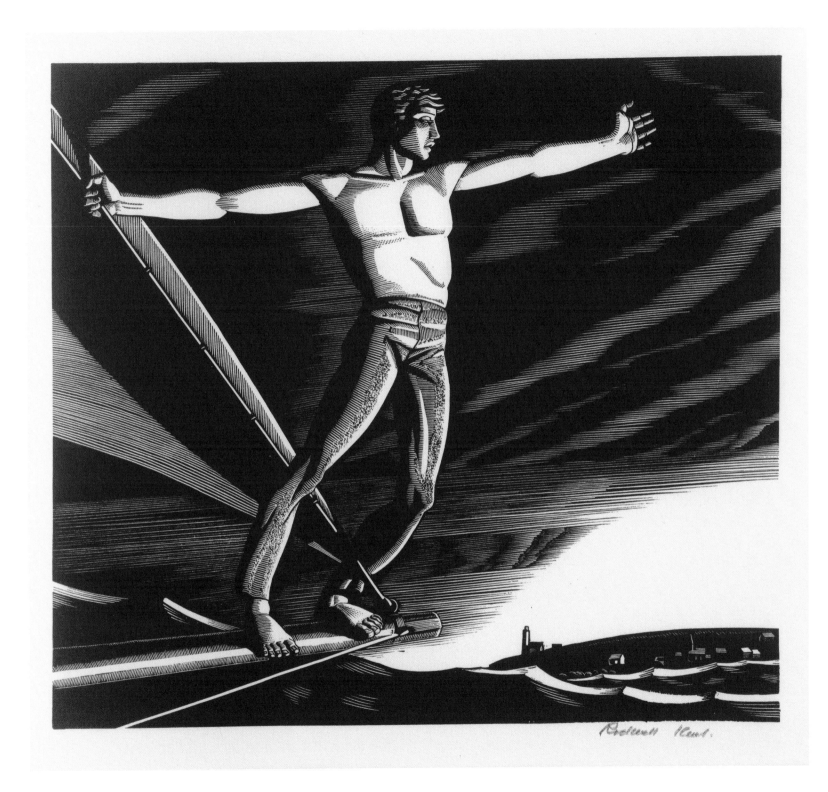

53. Rockwell Kent Homeport, 1931 wood engraving

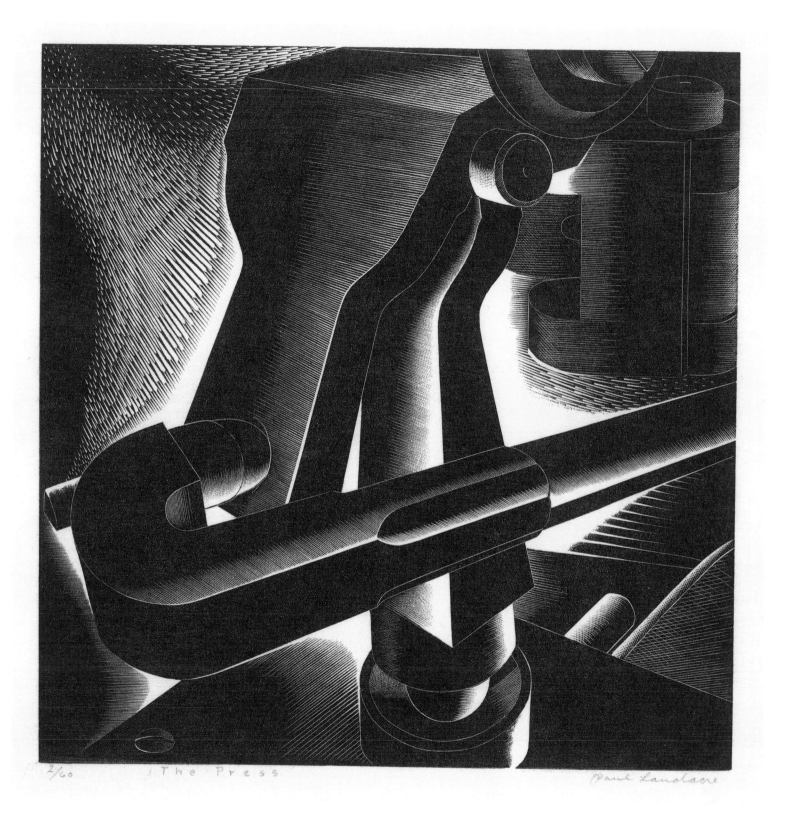

2/60 The Press Paul Landacre

54. Paul Landacre The Press, 1934 wood engraving

CHECKLIST OF THE EXHIBITION
CHECKLIST OF THE EXHIBITION

Prints are listed in alphabetical order by artist's last name. Measurements of intaglio prints are taken from the platemark; those for woodcuts, wood engravings, lithographs, and screenprints correspond to the image size. Dimensions are in inches. Height precedes width. All prints are from the Huntington Art Collections, unless otherwise noted.

Ida Abelman, 1910–2002
Wonders of Our Time, 1937
Lithograph
11⅝ × 15⅛ in.
Collection of Hannah S. Kully
Reproduced by permission of the estate of Ida Abelman
Plate #22

John Taylor Arms, 1887–1953
West Forty-Second Street, Night, 1922
Etching and aquatint
10¾ × 6⅞ in.
Collection of Hannah S. Kully
Plate #3

Boris Artzybasheff, 1899–1965
The Last Trumpet, 1937
Wood engraving
11⅜ × 7¹⁵⁄₁₆ in.
Collection of Hannah S. Kully
Plate #7

Milton Avery, 1893–1965
Sally with a Beret, 1939
Drypoint
8 × 6⅜ in.
Collection of Hannah S. Kully

Peggy Bacon, 1895–1987
Aesthetic Pleasure, 1936
Etching
6 × 8½ in.
Gift of Mrs. Homer D. Crotty, 91.284.1

Peggy Bacon, 1895–1987
Casual Ablutions, 1931
Etching
11 × 7¹⁵⁄₁₆ in.
Collection of Hannah S. Kully
Plate #30

Peggy Bacon, 1895–1987
Dance at the League, 1919
Drypoint
7 × 10 in.
Collection of Hannah S. Kully

Peggy Bacon, 1895–1987
Frenzied Effort, 1925
Etching
5⅞ × 9 in.
Gift of Mrs. Homer D. Crotty, 91.284.4

Gustave Baumann, 1881–1971
Singing Woods, 1928
Color woodcut with aluminum leaf
12⅝ × 12⅝ in.
Collection of Hannah S. Kully
Plate #47

George Wesley Bellows, 1882–1925
Artists Judging Works of Art, 1916
Lithograph
14⅜ × 18⅞ in.
Collection of Hannah S. Kully

George Wesley Bellows, 1882–1925
Benediction in Georgia, 1916
Lithograph
15¾ × 19⅞ in.
Collection of Hannah S. Kully

George Wesley Bellows, 1882–1925
Billy Sunday, 1923
Lithograph
8⅞ × 16⅛ in.
Collection of Hannah S. Kully

George Wesley Bellows, 1882–1925
Preliminaries, 1916
Lithograph
15¹¹⁄₁₆ × 19⅜ in.
Collection of Hannah S. Kully
Plate #15

George Wesley Bellows, 1882–1925
The Sawdust Trail, 1917
Lithograph
25¼ × 19¹⁵⁄₁₆ in.
Collection of Hannah S. Kully

George Wesley Bellows, 1882–1925
A Stag at Sharkey's, 1917
Lithograph
18¾ × 23¾ in.
Gift of the Frances and Sidney Brody Charitable Fund, Inc., Kelvin L. Davis, Stan and Judith Farrar, Paul and Heather Haaga, Margery and Maurice H. Katz, Russel and Hannah Kully, Margaret Richards, The Virginia Steele Scott Foundation, Warren and Alyce Williamson, and Robert and Deborah Wycoff, 2001.12
Plate #14

George Wesley Bellows, 1882–1925
Tennis, 1921
Lithograph
18¼ × 20 in.
Collection of Hannah S. Kully

George Wesley Bellows, 1882–1925
Tennis Tournament, 1920
Lithograph
14⅞ × 18⅜ in.
Collection of Hannah S. Kully

Frank Benson, 1862–1951
Herons in a Pine Tree, 1918
Etching
13⅞ × 9⅞ in.
Collection of Hannah S. Kully

Thomas Hart Benton, 1889–1975
Cradling Wheat, 1939
Lithograph
9⅝ × 12 in.
Collection of Hannah S. Kully
© T. H. Benton and R.P. Benton
Testamentary Trusts/UMB Bank
Trustee/Licensed by VAGA,
New York, NY
Plate #40

Thomas Hart Benton, 1889–1975
Departure of the Joads, 1939
Lithograph
12¾ × 18⅜ in.
Collection of Hannah S. Kully
© T. H. Benton and R. P. Benton
Testamentary Trusts/UMB Bank
Trustee/Licensed by VAGA,
New York, NY
Plate #45

Thomas Hart Benton, 1889–1975
I Got a Gal on Sourwood Mountain, 1938
Lithograph
12½ × 9³⁄₁₆ in.
Collection of Hannah S. Kully

Thomas Hart Benton, 1889–1975
The Strike, 1933
Lithograph
9¾ × 10¾ in.
Collection of Hannah S. Kully

Thomas Hart Benton, 1889–1975
Wreck of the Ol' 97, 1944
Lithograph
10⅜ × 15 in.
Collection of Hannah S. Kully

Leon Bibel, 1912–1995
Descending, 1938
Color screenprint
14⅛ × 11⅛ in.
Collection of Hannah S. Kully
Reproduced courtesy of Park Slope
Gallery, Brooklyn, New York
Plate #25

Arnold Blanch, 1896–1968
Along the Hudson, n.d.
Lithograph
8⅞ × 12¹¹⁄₁₆ in.
Purchased with funds from The
Virginia Steele Scott Foundation, 85.29

Bernarda Bryson, 1903–2004
Pathetic Figure (Depression), 1929
Lithograph
10½ × 7¼ in.
Collection of Hannah S. Kully

Paul Cadmus, 1904–1999
The Fleet's In, 1934
Etching
7⁷⁄₁₆ × 14⅛ in.
Collection of Hannah S. Kully

Paul Cadmus, 1904–1999
Shore Leave, 1935
Etching
10⅜ × 11⁹⁄₁₆ in.
Collection of Hannah S. Kully

Paul Cadmus, 1904–1999
Stewart's, 1934
Etching
7¹⁵⁄₁₆ × 11¹⁵⁄₁₆ in.
Collection of Hannah S. Kully
© Jon F. Anderson, executor Paul
Cadmus Estate Collection
Plate #27

Minna Citron, 1896–1991
Demonstration, 1933
Lithograph
11¾ × 8⁹⁄₁₆ in.
Collection of Hannah S. Kully

Glenn O. Coleman, 1887–1932
Election Night Bonfire, 1928
Lithograph
12¼ × 17 in.
Collection of Hannah S. Kully

Howard Norton Cook, 1901–1980
Engine Room, 1930
Lithograph
10⅛ × 12¼ in.
Collection of Hannah S. Kully

Howard Norton Cook, 1901–1980
Greetings from the House of Weyhe, 1929
Wood engraving
7⅞ × 4⁷⁄₁₆ in.
Gift of Margery and Maurice H. Katz,
2002.30.2

Howard Norton Cook, 1901–1980
Harbor Skyline, 1930
Soft-ground etching and aquatint
9⁹⁄₁₆ × 11⅞ in.
Collection of Hannah S. Kully
Plate #1

Howard Norton Cook, 1901–1980
New England Church, 1931
Wood engraving
11⅜ × 8½ in.
Gift of Mrs. Homer D. Crotty, 91.284.14

Howard Norton Cook, 1901–1980
The New Yorker, 1930
Lithograph
17⅝ × 8⅝ in.
Collection of Hannah S. Kully

Richard Correll, 1904–1990
Air Raid Wardens, 1942
Linocut
10 × 15 in.
Collection of Hannah S. Kully

Miguel Covarrubias, 1904–1957
The Lindy Hop, 1936
Lithograph
13 × 10 in.
Collection of Hannah S. Kully
Reprinted by permission of the Estate
of Miguel Covarrubias
Plate #17

John Steuart Curry, 1897–1946
The Fugitive, 1935
Lithograph
12⅞ × 9⅜ in.
Collection of Hannah S. Kully
Plate #44

John Steuart Curry, 1897–1946
John Brown, 1939
Lithograph
14¾ × 10¹⁵⁄₁₆ in.
Collection of Hannah S. Kully

John Steuart Curry, 1897–1946
Manhunt, 1934
Lithograph
9¾ × 13¹⁵⁄₁₆ in.
Collection of Hannah S. Kully

John Steuart Curry, 1897–1946
Mississippi Noah, 1934
Lithograph
9⅞ × 13¾ in.
Gift of Mrs. Homer D. Crotty, 91.284.15

Pele (Phyllis) deLappe, b. 1916
Rumors of War, Washington, D.C., 1939
Lithograph
13⅞ × 18¾ in.
Collection of Hannah S. Kully
Reproduced by permission of Pele
deLappe.
Plate #51

Pedro De Lemos, 1882–1945
Top of the Hill, ca. 1924
Color linocut
8½ × 12 in.
Collection of Hannah S. Kully

John De Martelly, 1903–1979
Blue Valley Fox Hunt, 1936–37
Lithograph
12¾ × 16⅜ in.
Collection of Hannah S. Kully

Adolf Dehn, 1895–1968
Central Park at Night, 1934
Lithograph
9 × 12¾ in.
Collection of Hannah S. Kully
Plate #2

Burgoyne Diller, 1906–1965
Still Life on a Table, 1932
Lithograph
11⅜ × 9½ in.
Collection of Hannah S. Kully

Mabel Dwight, 1876–1955
The Clinch, 1928
Lithograph
9⅛ × 11¾ in.
Collection of Hannah S. Kully
Plate #13

Mabel Dwight, 1876–1955
Greetings from the House of Weyhe, 1928
Lithograph
7¹⁄₁₆ × 8⁷⁄₁₆ in.
Gift of Margery and Maurice H. Katz,
2002.30.1

Mabel Dwight, 1876–1955
Night Work, 1931
Lithograph
10 × 7⅝ in.
Collection of Hannah S. Kully

Mabel Dwight, 1876–1955
"Stick 'Em Up," 1928
Lithograph
10¼ × 10¼ in.
Collection of Hannah S. Kully

Fritz Eichenberg, 1901–1990
Lumber Yard, 1936
Wood engraving
10³⁄₁₆ × 8¼ in.
Collection of Hannah S. Kully

Fritz Eichenberg, 1901–1990
Subway, 1934
Wood engraving
6¼ × 4¾ in.
Collection of Hannah S. Kully
© Fritz Eichenberg Trust/Licensed
to VAGA, New York, NY
Plate #21

Ralph Farbi, 1894–1975
The Race, 1939
Etching
7 × 8¹⁵⁄₁₆ in.
Collection of Hannah S. Kully

Isaac Friedlander, 1890–1968
Bowery Mission, 1935
Drypoint
9¾ × 11⅞ in.
Collection of Hannah S. Kully

Isaac Friedlander, 1890–1968
Coney Island, 1932
Etching and aquatint
10½ × 8⅛ in.
Collection of Hannah S. Kully
Plate #18

Wanda Gág, 1893–1946
Backyard Corner, 1930
Lithograph
10⅜ × 12⅞ in.
Gift of Mrs. Homer D. Crotty, 91.284.24

Michael J. Gallagher, 1898–1965
Lacawanna Valley, 1939
Carborundum print
7⅜ × 12¾ in.
Collection of Hannah S. Kully

Michael J. Gallagher, 1898–1965
Miner's Kitchen, 1938
Etching and aquatint
8⅞ × 13⅛ in.
Collection of Hannah S. Kully

Michael J. Gallagher, 1898–1965
Scranton Coal Miners, ca. 1938
Etching and carborundum print
7¼ × 14½ in.
Collection of Hannah S. Kully
Plate #26

Emil Ganso, 1895–1945
Village at Night, n.d.
Etching and aquatint
9 × 10¹⁵⁄₁₆ in.
Gift of Mrs. Homer D. Crotty, 91.284.26
Plate #33

Gerald Geerlings, 1897–1998
Black Magic, 1929
Aquatint
11¾ × 6⅝ in.
Collection of Hannah S. Kully

Gerald Geerlings, 1897–1998
Civic Insomnia, 1932
Aquatint
10¹⁵⁄₁₆ × 14⅛ in.
Collection of Hannah S. Kully

Franz Geritz, 1895–1945
Craters, Mono Lake, 1927
Linocut
7⅝ × 12⅛ in.
Gift of Mrs. Homer D. Crotty, 91.284.31
Plate #48

Douglas Gorsline, 1913–1985
Brooklyn Local, 1945
Engraving
8⁵⁄₁₆ × 7 in.
Collection of Hannah S. Kully

Marion Greenwood, 1909–1970
New Year's Eve, 1940
Lithograph
11⅞ × 9¼ in.
Collection of Hannah S. Kully

Jolán Gross-Bettelheim, 1900–1972
Assembly Line, 1942
Lithograph
15¹⁵⁄₁₆ × 11¹⁵⁄₁₆ in.
Collection of Hannah S. Kully
Plate #50

Jolán Gross-Bettelheim, 1900–1972
Bridge #1, ca. 1940
Lithograph
14 × 10⅛ in.
Collection of Hannah S. Kully

Robert Gwathmey, 1903–1988
The Hitchhiker, ca. 1937
Color screenprint
16⅞ × 13⅛ in.
Collection of Hannah S. Kully
© Estate of Robert Gwathmey/Licensed
by VAGA, New York, NY
Plate #46

Robert Gwathmey, 1903–1988
Topping Tobacco, 1947
Color screenprint
13⁵⁄₁₆ × 8⅞ in.
Collection of Hannah S. Kully
© Estate of Robert Gwathmey/Licensed
by VAGA, New York, NY
Plate #43

Childe Hassam, 1859–1935
The Dutch Door, 1915
Etching
8½ × 10 in.
Gift of The Virginia Steele Scott
Foundation, 84.45.16

Childe Hassam, 1859–1935
The Lion Gardiner House, East Hampton,
1920
Etching
9¹³⁄₁₆ × 14⅛ in.
Collection of Hannah S. Kully
Plate #32

Childe Hassam, 1859–1935
The White Kimono, 1915
Etching
7⁷⁄₁₆ × 11 in.
Gift of The Virginia Steele Scott
Foundation, 84.45.7
Plate #31

Albert Heckman, 1893–1971
Windblown Trees, n.d.
Lithograph
11⅜ × 16¹⁄₁₆ in.
Gift of the Ledler Foundation, 86.7.11

Riva Helfond, 1910–2002
Patterns for Victory, 1943
Color screenprint
15 × 8⅞ in.
Collection of Hannah S. Kully
Plate #52

Edward Hopper, 1882–1967
Night Shadows, 1921/1924
Etching
7 × 8¾ in.
Collection of Hannah S. Kully
Plate #10

Peter Hurd, 1904–1984
Sermon from Revelations, n.d.
Lithograph
10 × 13½ in.
Gift of Mrs. Homer D. Crotty, 91.284.35

Rockwell Kent, 1882–1971
Homeport, 1931
Wood engraving
6½ × 7⅜ in.
Collection of Hannah S. Kully
Plate #53

Gene Kloss, 1903–1996
Snow and Adobe, 1934
Drypoint and aquatint
8⅛ × 11½ in.
Collection of Hannah S. Kully

Alexander Zerdin Kruse, 1890–1972
Musical Clown, n.d.
Lithograph
14¾ × 8⅜ in.
Gift of the Kruse Family Trust, 96.34.10

Walt Kuhn, 1880–1949
Mirabelle, 1925
Lithograph
14¾ × 9⅝ in.
Collection of Hannah S. Kully

Yasuo Kuniyoshi, 1889–1953
Burlesque Queen, 1933
Lithograph
11⅝ × 9⁹⁄₁₆ in.
Collection of Hannah S. Kully

Paul Landacre, 1893–1963
Coachella Valley, ca. 1935
Wood engraving
6 × 12³⁄₁₆ in.
Collection of Hannah S. Kully
Figure #5

Paul Landacre, 1893–1963
Death of a Forest, 1938
Wood engraving
8⁵⁄₁₆ × 11⅛ in.
Collection of Hannah S. Kully
Plate #49

Paul Landacre, 1893–1963
Laguna Cove, 1935
Wood engraving
5¼ × 7⅛ in.
Artist's Proof
Purchased with funds from The
Virginia Steele Scott Foundation,
86.22.4

Paul Landacre, 1893–1963
Laguna Cove, 1935
Wood engraving
5¼ × 7⅛ in.
Purchased with funds from The
Virginia Steele Scott Foundation,
86.22.5

Paul Landacre, 1893–1963
Laguna Cove, 1935
Wood engraving
5¼ × 7⅛ in.
Collection of Hannah S. Kully

Paul Landacre, 1893–1963
The Press, 1934
Wood engraving
8⁵⁄₁₆ × 8⁵⁄₁₆ in.
Gift of Mrs. Homer D. Crotty, 91.284.40
Plate #54

Paul Landacre, 1893–1963
Rima, 1933
Wood engraving
8½ × 6 in.
Gift of Mrs. Homer D. Crotty, 91.284.46

Paul Landacre, 1893–1963
Sultry Day, 1935
Wood engraving
8 × 6 in.
Collection of Hannah S. Kully

Armin Landeck, 1905–1984
Manhattan Vista, 1934
Drypoint
10⅛ × 8⅝ in.
Collection of Hannah S. Kully
Plate #5

Armin Landeck, 1905–1984
Studio Interior No. 1, 1935
Drypoint
7¹⁵⁄₁₆ × 10¹¹⁄₁₆ in.
Collection of Hannah S. Kully

Doris Lee, 1905–1983
Helicopter, 1948
Lithograph
8⅞ × 12 in.
Collection of Hannah S. Kully
Plate #42

Clare Leighton, 1898–1989
Snow Shovelers, New York, 1929
Wood engraving
8¹⁄₁₆ × 6 in.
Collection of Hannah S. Kully
Reproduced by permission of
David Leighton
Plate #23

Martin Lewis, 1881–1962
Chance Meeting, 1940–41
Drypoint
10½ × 7½ in.
Purchased with funds from The
Virginia Steele Scott Foundation, 86.14

Martin Lewis, 1881–1962
Corner Shadows, 1930
Drypoint and sand-ground etching
8⅜ × 8⅞ in.
Collection of Hannah S. Kully

Martin Lewis, 1881–1962
Down to the Sea at Night, 1929
Drypoint and sand-ground etching
8 × 13 in.
Collection of Hannah S. Kully
Plate #35

Martin Lewis, 1881–1962
Glow in the City, 1929
Drypoint
11¼ × 14¼ in.
Purchased with funds from Hannah
and Russel Kully, 2006.21
Plate #8

Martin Lewis, 1881–1962
Stoops in Snow, 1930
Drypoint and sand-ground etching
9⅞ × 15 in.
Collection of Hannah S. Kully
Plate #9

Martin Lewis, 1881–1962
Subway Steps, 1931
Etching
13⅝ × 8¼ in.
Gift of Mrs. Homer D. Crotty, 91.284.63

Martin Lewis, 1881–1962
Wet Night, Route 6, 1933
Drypoint
8⅞ × 14¹¹⁄₁₆ in.
Collection of Hannah S. Kully
Plate #34

Charles Locke, 1889–1983
Table d'Hote, n.d.
Lithograph
11⅝ × 8⅛ in.
Collection of Hannah S. Kully

Louis Lozowick, 1892–1973
Coney Island (Luna Park), ca. 1928
Lithograph
12¹³⁄₁₆ × 8½ in.
Collection of Hannah S. Kully

Louis Lozowick, 1892–1973
Granaries of Democracy, 1943
Lithograph
13 × 8½ in.
Collection of Hannah S. Kully
Plate #38

Louis Lozowick, 1892–1973
Hanover Square, 1929
Lithograph
14¹¹⁄₁₆ × 8¹⁵⁄₁₆ in.
Collection of Hannah S. Kully

Louis Lozowick, 1892–1973
Still Life #2 (Still Life with Apple), 1929
Lithograph
10¼ × 13³⁄₁₆ in.
Collection of Hannah S. Kully

Adriaan Lubbers, 1892–1954
South Ferry, 1929
Lithograph
14½ × 10⅜ in.
Collection of Hannah S. Kully

Luigi Lucioni, 1900–1988
Big Elm, 1934
Etching
9¹⁵⁄₁₆ × 7⅞ in.
Purchased with funds from The
Virginia Steele Scott Foundation, 85.17

Samuel Margolies, 1898–1974
Builders of Babylon, 1949
Aquatint
14¼ × 11 in.
Collection of Hannah S. Kully

Samuel Margolies, 1898–1974
Man's Canyons, 1936
Etching and aquatint
11⅞ × 8⅞ in.
Collection of Hannah S. Kully
Plate #6

Samuel Margolies, 1898–1974
Men of Steel, ca. 1940
Drypoint
14¹⁵⁄₁₆ × 11¾ in.
Collection of Hannah S. Kully
Plate #4

John Marin, 1870–1973
Downtown, The El, 1924
Etching
7 × 8⅞ in.
Collection of Hannah S. Kully

Kyra Markham, 1891–1967
Night Club, 1935
Lithograph
13⅞ × 10½ in.
Collection of Hannah S. Kully
Plate #16

Reginald Marsh, 1898–1954
Bread Line—No One Has Starved, 1932
Etching and engraving
6¹⁵⁄₁₆ × 11⅞ in.
Collection of Hannah S. Kully
© 2007 Estate of Reginald Marsh/Art
Students League/Artist Rights Society
(ARS), New York
Plate #29

Reginald Marsh, 1898–1954
Girl Walking in Front of Brownstone,
ca. 1950
Lithograph
13½ × 8¾ in.
Collection of Hannah S. Kully

Fletcher Martin, 1904–1979
Trouble in Frisco, ca. 1938
Lithograph
11³⁄₁₆ in. diameter
Gift of Mrs. Homer D. Crotty, 91.284.67

Mildred McMillen, 1884–ca. 1940
House Tops, 1918
Woodcut
17¼ × 14¾ in.
Collection of Hannah S. Kully

George Jo Mess, 1898–1962
Chicago, 1938
Aquatint and etching
6⅜ × 8⅛ in.
Collection of Hannah S. Kully

Arthur Henry Thomas Millier,
1893–1975
*Monday Morning (Bunker Hill,
Los Angeles)*, 1922
Etching
6⅜ × 7¾ in.
Gift of The Virginia Steele Scott
Foundation, 84.66.12
Figure #1

John J. A. Murphy, 1888–1967
Shadow Boxers, 1925
Woodcut
8 × 9 in.
Collection of Hannah S. Kully

Joseph Pennell, 1866–1926
Water Street Stairs, New York, 1919
Etching
12 × 6 in.
Gift of Bradford and Christine Mishler,
98.5.5

Carl Pickhardt, b. 1908
Washerwomen, 1935
Lithograph
18⅜ × 11 in.
Collection of Hannah S. Kully

Mildred Rackley, 1906–1992
Boogie Woogie (Jumping Jives), 1940
Color woodcut
5 × 6⅛ in.
Collection of Hannah S. Kully

Mildred Rackley, 1906–1992
Boogie Woogie, 1940
Color screenprint
10⅜ × 14⁵⁄₁₆ in.
Collection of Hannah S. Kully

William Rice, 1873–1963
Magnolia Grandiflora, ca. 1925
Color woodcut
11⅞ × 14⅜ in.
Collection of Hannah S. Kully

Donato (Dan) Rico, 1912–1985
Bystander, ca. 1936–42
Wood engraving
8¹⁄₁₆ × 6 in.
Collection of Hannah S. Kully
Plate #24

Arnold Ronnebeck, 1885–1947
Wall Street, 1925
Lithograph
12⅝ × 6¾ in.
Collection of Hannah S. Kully

Millard Sheets, 1907–1989
Family Flats, ca. 1933
Lithograph
15⅝ × 21⅞ in.
Gift of Mrs. Homer D. Crotty,
91.284.164

Harry Shokler, 1896–1978
Coney Island, ca. 1940
Color screenprint
12½ × 16 in.
Collection of Hannah S. Kully
Plate #19

Henrietta Shore, 1880–1963
Banana Tree, n.d.
Lithograph
7⁹⁄₁₆ × 6 in.
Gift of the Ledler Foundation, 86.7.35

John Sloan, 1871–1951
Amateur Lithographers, 1908
Lithograph
16½ × 15½ in.
Collection of Gary, Brenda, and
Harrison Ruttenberg

John Sloan, 1871–1951
Anschutz on Anatomy, 1912
Etching
7⅜ × 8⅞ in.
Collection of Gary, Brenda, and
Harrison Ruttenberg

John Sloan, 1871–1951
Barber Shop, 1915
Etching and aquatint
10 × 11¾ in.
Partial and promised gift of Gary,
Brenda, and Harrison Ruttenberg
Plate #11

John Sloan, 1871–1951
The Boar Hunt, 1904
Graphite on tissue
3¾ × 5¹¹⁄₁₆ in.
Partial and promised gift of Gary,
Brenda, and Harrison Ruttenberg

John Sloan, 1871–1951
The Boar Hunt, 1904
Etching
4¹⁄₁₆ × 5¾ in.
State 1 of 4
Partial and promised gift of Gary,
Brenda, and Harrison Ruttenberg

John Sloan, 1871–1951
The Boar Hunt, 1904
Etching
4³⁄₁₆ × 5⅞ in.
State 2 of 4
Partial and promised gift of Gary,
Brenda, and Harrison Ruttenberg

John Sloan, 1871–1951
The Boar Hunt, 1904
Etching
4 × 5¾ in.
State 3 of 4
Partial and promised gift of Gary,
Brenda, and Harrison Ruttenberg

John Sloan, 1871–1951
The Boar Hunt, 1904
Etching
4 × 5⅞ in.
State 4 of 4
Partial and promised gift of Gary,
Brenda, and Harrison Ruttenberg

John Sloan, 1871–1951
Bonfire, 1920
Etching
5¼ × 7⅜ in.
Partial and promised gift of Gary,
Brenda, and Harrison Ruttenberg

John Sloan, 1871–1951
The Connoisseurs of Prints, 1905
Etching
4⅞ × 6¹³⁄₁₆ in.
Collection of Gary, Brenda, and
Harrison Ruttenberg

John Sloan, 1871–1951
Fun, One Cent, 1905
Etching
4⅞ × 6¹³⁄₁₆ in.
Collection of Gary, Brenda, and
Harrison Ruttenberg
Plate #12

John Sloan, 1871–1951
Hell Hole, 1917
Etching and aquatint
7⅞ × 9⅝ in.
Collection of Gary, Brenda, and
Harrison Ruttenberg

John Sloan, 1871–1951
Love on the Roof, 1914
Etching
5¹⁵⁄₁₆ × 4⅜ in.
Collection of Gary, Brenda, and
Harrison Ruttenberg

John Sloan, 1871–1951
The Picture Buyer, 1911
Etching
5¼ × 7 in.
Collection of Gary, Brenda, and
Harrison Ruttenberg

John Sloan, 1871–1951
The Show Case, 1905
Etching
4⅞ × 6⅞ in.
Partial and promised gift of Gary,
Brenda, and Harrison Ruttenberg

John Sloan, 1871–1951
Sunbathers on the Roof, 1941
Etching
6 × 7 in.
Collection of Gary, Brenda, and
Harrison Ruttenberg
Figure #2

John Sloan, 1871–1951
Sunbathers on the Roof, 1941
Gold-plated copper etching plate
6 × 7 in.
Collection of Gary, Brenda, and
Harrison Ruttenberg
Figure #3

Raphael Soyer, 1899–1987
The Mission, 1933
Lithograph
12⅛ × 17¾ in.
Collection of Hannah S. Kully
Plate #28

Benton Spruance, 1904–1967
American Pattern—Barn, 1940
Lithograph
7⅝ × 14 in.
Collection of Hannah S. Kully
Plate #39

Benton Spruance, 1904–1967
The People Work—Evening, 1937
Lithograph
13⅜ × 19 in.
Collection of Hannah S. Kully

Benton Spruance, 1904–1967
The People Work—Morning, 1937
Lithograph
13¾ × 19 in.
Collection of Hannah S. Kully

Benton Spruance, 1904–1967
The People Work—Night, 1937
Lithograph
13¾ × 19 in.
Collection of Hannah S. Kully

Benton Spruance, 1904–1967
Road from the Shore, 1936
Lithograph
10⅛ × 14½ in.
Collection of Hannah S. Kully
Plate #36

Bernard Steffen, 1907–1980
Haying, 1946
Color screenprint
10⅛ × 8⅛ in.
Collection of Hannah S. Kully
Plate #41

Harry Sternberg, 1904–2001
Construction, 1937
Lithograph
13⅞ × 10⅞ in.
Collection of Hannah S. Kully

Harry Sternberg, 1904–2001
Steel (Forest of Flame), 1938
Lithograph
12½ × 16⅜ in.
Collection of Hannah S. Kully

James Swann, 1905–1985
Night in Chicago, 1940
Drypoint
7 × 11 in.
Collection of Hannah S. Kully

Charles Turzak, 1899–1986
Chicago River, ca. 1930
Woodcut
11⅜ × 9⁵⁄₁₆ in.
Collection of Hannah S. Kully

Charles Turzak, 1899–1986
Man with Drill, ca. 1935
Woodcut
12⅛ × 9⅜ in.
Collection of Hannah S. Kully
Printed by permission of Joan Turzak
van Hees, daughter of Charles
Turzak; Charles Turzak Studio/
Gallery, Orlando, Florida
Plate #20

Grant Wood, 1891–1942
February, 1940
Lithograph
8⅞ × 11¹³⁄₁₆ in.
Collection of Hannah S. Kully

Grant Wood, 1891–1942
January, 1937
Lithograph
9 × 11⅞ in.
Collection of Hannah S. Kully
© Estate of Grant Wood/Licensed by
VAGA, New York, NY
Figure #4

Grant Wood, 1891–1942
July Fifteenth, 1939
Lithograph
9 × 12 in.
Purchased with funds from The
Virginia Steele Scott Foundation, 86.20
© Estate of Grant Wood/Licensed by
VAGA, New York, NY
Plate #37

Grant Wood, 1891–1942
Sultry Night, 1939
Lithograph
9 × 11¾ in.
Collection of Hannah S. Kully

GLOSSARY OF TERMS

GLOSSARY OF TERMS

Aquatint

Aquatint is an **intaglio** technique related to **etching** in which the plate is dusted or brushed with a grainy, acid-resistant resin. Acid bites into the tiny spaces between the grains of resin, creating ink-retaining pits that produce areas of tone when printed.

Color Screenprint

A printing process based on stenciling in which color is forced through the unmasked area of a fine screen onto the paper beneath. Each separate color requires its own stencil. Also known as silkscreen printing or serigraphy.

Drypoint

Drypoint is an **intaglio** process in which an artist creates an image directly on a metal plate using a pointed steel tool. In an etching, acid bites the line into the plate. In a drypoint, the artist's tool scores a shallow line that has a raised burr on either side. When inked, the burr creates a softer line than possible with etching. However, because the burr wears down over time, drypoints are usually limited to editions of fewer than fifty **impressions.** Drypoint is often used in conjunction with **etching** to enhance an image after the ground has been removed from the plate.

Edition

A series of **impressions,** usually created at the same time and supervised by the artist. Many modern artists will number prints to indicate the number of the impression and the size of the edition. For example the number 59/100 would indicate that the print was the 59th impression out of an edition of 100 prints.

Etching

A metal plate is covered in a waxy or resinous coating called a **ground,** which is resistant to acid. The artist uses a sharp, pointed tool to scratch through the ground, exposing the metal plate. The plate is then covered in acid, which bites into the exposed areas to produce incised lines, while the ground protects the unexposed areas of the plate. In printing, the plate is inked and its surface is wiped, leaving ink in the lines that have been bitten by the acid. When the plate is pressed with a sheet of slightly damp paper, the paper picks up the ink from the grooves. Etching is an **intaglio** process.

Ground

A waxy or resinous substance used to protect a metal plate from acid.

Impression

A single print.

Intaglio

A type of printmaking where the image is incised into the surface of a **matrix,** often a metal plate. Ink fills the recessed lines and excess ink is wiped

from the plate, which is then run through a press, transferring the image to paper. **Etching, aquatint,** engraving, and **drypoint** are intaglio methods of printmaking.

Linocut

A **relief** process that is similar to **woodcut,** except that linoleum is used as the **matrix** instead of wood.

Lithography

Using a greasy medium that resists water and can withstand acid, the artist creates an image on a stone (traditionally limestone) or other flat surface, such as a metal plate. The stone or plate is treated with a mixture of chemicals so that areas without the image repel ink and areas with the image attract it. Ink is rolled onto the printing surface, adhering only to the image, and both plate and paper are put through a press. Lithography is a **planographic** process.

Matrix

The surface on which an artist makes the image for a print, which is inked and pressed against paper to create an **impression.**

Planographic

Prints made from inking the flat surface of a **matrix,** on which ink has adhered to the design created by the artist, rather than ink held in cuts made into the matrix, as in **intaglio** processes, or from the surface of a matrix into which areas have been cut away, as in **relief** printing. **Lithography** is a planographic process.

Relief

In relief printing, lines are created by carving away a **matrix,** usually wood or linoleum. The raised lines that remain are inked to make the image, while the recessed, carved areas are left blank. **Woodcut, linocut,** and **wood engraving** are forms of relief printmaking.

State

During the printmaking process, anytime an artist makes changes to the **matrix** of a print between **editions** constitutes a different state.

Woodcut

An artist draws a design on a plank of wood and then carves away wood to either side of the design with a knife. The drawn lines become raised above the surface of the block. Ink is then applied to the raised lines and transferred when paper is pressed against it. Woodcut is a **relief** process.

Wood Engraving

A variation of **woodcut.** Rather than carve out a design on the side of a plank of wood, the artist uses the end grain of a wood block, typically a hardwood such as boxwood. The wood engraving method allows for greater degree of detail than the woodcut because one can carve in any direction without taking into account the grain of the wood, and the artist uses tools that produce finer lines than are possible with woodcut. Wood engraving is a **relief** process.